NOTORIOUS

JEFFERSON COUNTY

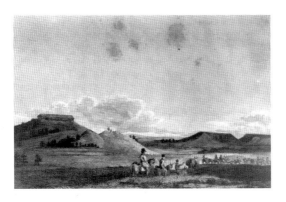

This view of the table lands shows members of the Stephen H. Long expedition in 1822, among the first explorers to document the region. *Library of Congress, Prints & Photographs Division.*

NOTORIOUS

JEFFERSON COUNTY

COUNTY | FRONTIER MURDER & MAYHEM

CAROL TURNER

THE
History
PRESS

Published by The History Press
Charleston, SC 29403
www.historypress.net

Copyright © 2010 by Carol Turner
All rights reserved

Cover images: All mug shots courtesy of the Colorado State Archives; other images courtesy
of the Library of Congress, Prints & Photographs Division.

First published 2010

Manufactured in the United States

ISBN 978.1.59629.954.2

Turner, Carol.
Notorious Jefferson County : frontier murder and mayhem / Carol Turner.
p. cm.
Includes bibliographical references.
ISBN 978-1-59629-954-2
1. Murder--Colorado--Jefferson County--History. I. Title.
HV6533.C6T87 2010
364.152'30978884--dc22
2010030763

For Richard and Joss, with love.

Contents

Contents

Acknowledgements

M any thanks to Troy Rodriquez at the Golden Cemetery for his help in hunting down several graves and to Kenton Forrest at the Colorado Railroad Museum for sharing his knowledge about Denver's regional tram system at the turn of the twentieth century. I also owe thanks to the helpful folks at the Colorado State Archives, Standley Lake Library, Golden Library and Denver Public Library. I am extremely grateful to the wonderful people who built and maintain the Colorado Historic Newspapers Collection. I owe special thanks to Juliet Johnson and Francesca Redwine, descendants of Concetta and Stella Forgione, for sharing their extensive knowledge of the Garramone case and insight into their ancestors. I'm also grateful to my brother, Richard Turner, for his beautiful drawings and to John and Lynn Turner for their continued support, critique and advice.

Introduction

These stories, taken primarily from the pages of the county's earliest newspapers, paint a fascinating picture of crime and punishment in early Jefferson County. As it sometimes is today, justice a century ago was a matter of hit-and-miss, with extremes ranging from a midnight lynching to twenty-four hours in a jail cell for a coldblooded murder.

Many place names mentioned will be familiar to Jefferson County readers; others have long been forgotten, the old settlements wiped away by a century of development. For the latter cases, I've hunted down where events took place and identified the locations using the modern names. I was intrigued to discover that a couple of areas seemed to be hot spots for murder and mayhem.

One more thing: the newspaper reporters of the day had a casual attitude about spelling people's names correctly. I've tried to cross-check against census and marriage records, but those aren't particularly reliable, either. If I've used one of the numerous wrong spellings for the name of someone's ancestor, I do apologize.

The Case of the
Lovelorn Prodigy (1919)

Back about the turn of the twentieth century, tuberculosis was still destroying many lives. Colorado became a popular destination for those suffering from this malady—then called consumption—because of its dry climate. Fresh air and Rocky Mountain sunshine were considered to be instrumental in the recovery of many patients. In 1904, Dr. Charles Spivak founded the Jewish Consumptives Relief Society (JCRS). Located in Edgewater on West Colfax between Pierce and Kendall Streets, JCRS was a sprawling complex on one hundred acres of land with thirty-five buildings of various shapes and sizes. Dr. Spivak, a Russian Jew, took in anyone who needed care. Many people volunteered their services and donated money. A farm associated with the society produced fish, poultry, grain and vegetables.

In August 1919, one permanent patient at the hospital was a twenty-five-year-old musical prodigy. Isadore Victor had traveled a long way from his humble beginnings in Streshin, Russia (today's Belarus). When he was six years old, he was discovered by a blind fiddler, who overheard the child playing on a home-made reed instrument "in the manner of a fife."[1] Isadore's father was a physician, and the fiddler approached him and offered to teach music to the boy without charge because of his great talent. Isadore was given a fiddle that was almost too big for his hands, and within a month he had surpassed what the fiddler could teach him.

He moved on to another tutor but soon developed beyond this man's abilities as well. His father then took young Isadore to the larger town of Mogilev, where a series of instructors trained him until the age of twelve. At that point, Isadore was sent on to Kiev, the capital of Ukraine, where he

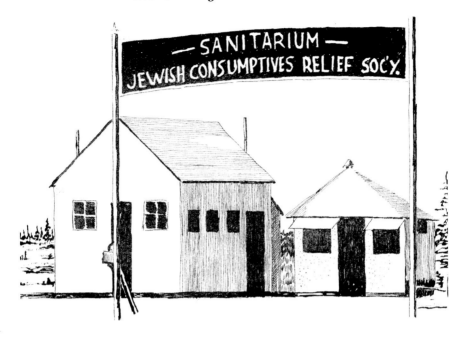

The front entrance to the Jewish Consumptives Relief Society. *Drawing by Richard Turner, from* a Denver Post *photo.*

became a violin star at the conservatory there. He also organized a stringed orchestra that became well known in Kiev.

He next entered the music conservatory in Warsaw, Poland, and joined the world-famous Warsaw Philharmonic orchestra. Isadore developed a talent on the piano that nearly equaled his skills on the violin.

Sometime during this period, he met and developed a close friendship with the noted Russian violinist Mischa Elman.

Isadore then spent some time traveling with a Russian operatic company. All of this happened before he reached the age of seventeen, at which time his father died.

Isadore's two brothers had immigrated to Canada, and after the death of his father, the teenage prodigy and his mother followed them to Winnipeg. The freezing climate there soon wreaked havoc on Isadore's health, and he was diagnosed with tuberculosis. In 1914, he came to the United States and settled in Denver, hoping to recuperate. There he tried to teach music, but his ill health soon put an end to that. He became a permanent resident of Dr. Spivak's sanitarium. He played occasionally for the other patients, but his

musical career was otherwise at a standstill.

In 1917, the year Isadore declared his intention to become a U.S. citizen, his famous friend Mischa Elman arrived in Denver on a concert tour and learned that Isadore was living in the sanitarium. He came to visit and, out of regard for Isadore, treated all of the patients there to a free concert.

After Isadore had been living at JCRS for five years, a pretty young nurse, Bessie Marold, came from the East Coast and took a job at the sanitarium. Twenty-two-year-old Bessie had been an army nurse during World War I at Camp Mills, New York. Her own health suffered during an influenza epidemic there, and she came to Colorado for relief.

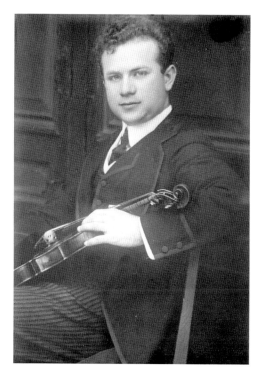

Isadore Victor's friend, Russian violinist Mischa Elman, enjoyed a long, successful career. *Library of Congress, Prints & Photographs Division.*

She stayed with friends, the Owens family, who lived on the middle Golden Road, which is today's Thirty-second Avenue in Wheat Ridge.

About the time of her arrival, Isadore's condition grew much worse, and long months passed while he lay near death. Bessie kept vigil at his bedside, nursing him slowly back to health. As Isadore regained his strength, he fell in love with her. When he had recovered sufficiently, he asked her to marry him.

Isadore was a small man—five foot four and about 115 pounds, with red hair. Though one reporter described him as a "handsome, brown-eyed boy,"[2] Bessie did not return his feelings, and she had become involved with a doctor at the sanitarium. She told him no.

The lovelorn Isadore could not accept her refusal. He asked her again and again, and Bessie continued to refuse his offers. His entreaties soon took on a more ominous tone, and he finally threatened to kill her and himself if she would not marry him. Bessie discussed these threats with her boss, Dr. Hill, but neither of them treated the statements seriously.

Isadore continued to escalate. More than once he went into town and purchased a revolver. He brought the gun into the sanitarium and waved it in Bessie's face. Each time he did this, she gently removed the weapon from his hands and got rid of it.

Despite the continued warning signs, nothing was done about Isadore's threats and behavior. Bessie and the others considered his histrionics a part of his "emotional, temperamental, artistic nature."[3] Isadore was careful to never make his threats in the presence of the sanitarium's doctors.

On the night of August 19, 1919, Isadore caught sight of Bessie and her doctor friend. The next morning, he went into Denver and purchased a .32-caliber revolver. On August 20, 1919, about mid-afternoon, Isadore and Bessie were strolling together in the courtyard of the hospital. Suddenly, Isadore pulled out the revolver and shot the woman who had saved his life.

A Denver man named Worley was working on the roof of one of the sanitarium's buildings. He heard the shot and hurried down to the ground. He saw Bessie Marold on her knees, begging and screaming for her life, and saw Isadore shoot her again.

Isadore put three bullets into Bessie's body—two into her heart and a third in her abdomen. After the third bullet, Bessie finally dropped to the ground.

Another patient at the hospital, Morris Ratner, was nearby when he heard shots. He ran toward the noise and found Bessie on the ground, an unsteady Isadore standing over her, holding the muzzle of the gun to his own forehead. Isadore was so weak that he apparently couldn't pull the trigger, and as Ratner took the pistol from him, he muttered, "Woe is to me."[4]

A doctor at the sanitarium, Dr. Marshak, arrived quickly. He picked Bessie up and carried her in to a bed, but she died after a couple of minutes without speaking.

Jefferson County sheriff Albert Jones arrived from Golden and arrested Isadore, taking him out of the hospital and throwing him in jail. Isadore refused to say a word.

The next morning, Coroner William Woods held an inquest, during which the coroner's jury discussed the facts only a few minutes before finding that Bessie Marold had died at the hands of Isadore Victor, with felonious intent. They ruled that Isadore had made advance plans for the killing—he purchased the revolver and practiced shooting. The district attorney charged Isadore with premeditated murder. During the hearing, Isadore sat mute and unmoving.

Meanwhile, Bessie's body was shipped back to New York for burial by her family.

Isadore's trial was scheduled for the November 1919 term, but the case was postponed because of his ill health and because his friends were still raising money for a defense. They intended to prove that he was temporarily insane when he shot Bessie Marold. His attorney, Thomas Herrington, released a statement, reiterating the "artistic temperament" defense:

> *Isadore is not a murderer. What happened on Aug. 18* [sic], *1919, at the sanitarium was in a moment's mental aberration, the breakdown of a highly artistic and high-strung temperament, when she told him in scorn that she had never loved him after he had seen her in another man's embrace.*[5]

By February 1920, newspaper notices declared that Isadore might never get to trial because he was critically ill. While in jail, he suffered repeated severe hemorrhages, which doctors said would eventually kill him.

Ironically, Isadore found his desperate circumstances to be profoundly inspiring. During his incarceration, he kept busy in his cell, writing compositions for the violin and piano. These he submitted to the Society for the Publication of American Music in New York. While in jail, he also had another visit from his loyal friend, Mischa Elman.

At the end of February 1920, authorities took him to St. Anthony's hospital in Denver. Doctors did not expect him to recover, but he did. Defying all expectations, Isadore was soon back in the lockup. About the third week of March, he received word that six of his compositions created in jail had been accepted by the music society for publication. Several of the pieces had been named appropriately for his situation: "Remorse," "Awakening" and "Serenade." He dedicated one of the works to Mischa Elman but none to the object of his affection, Bessie Marold. Even the sheriff's pianist wife, Mrs. Nellie Jones, got into the act, playing Victor's compositions for an audience.

Fifteen months after the murder, Isadore still had not gone to trial because of his health. Although he improved over the summer of 1920—rejuvenated with the publication of his music and by support from friends and admirers—he worsened again when the cold weather returned. In November 1920, he was once again reported as being near death from tuberculosis and unable to stand trial. His physicians gave him less than a month to live.

Five months later, in March 1921, he was again said to be nearing death. This was repeated once more in November 1921—the miraculously still-alive Isadore was near death, could not stand trial and probably never would.

The following March 1922, two and a half years after the murder of Bessie Marold, Isadore's doctor reported that he was in the last stages of

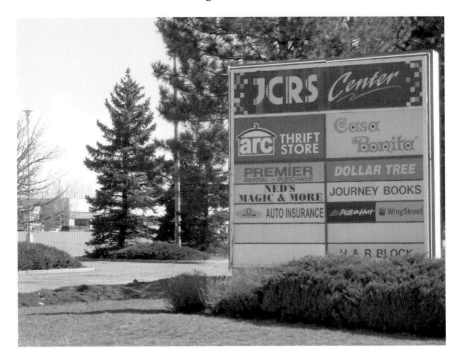

The JCRS Center at Colfax and Pierce in Edgewater was built on the site of the sanitarium. *Photo by the author.*

tuberculosis and would never be able to withstand the rigors of a trial. This time the doctor must have been right, because Isadore Victor was mentioned no more after that.

Dr. Spivak died in Denver on October 17, 1927. The Jewish Consumptives Relief Society carried on with its work but changed its focus in the 1950s to cancer research. In 1957, part of the grounds was purchased by developers who built the JCRS Center, a shopping mall on West Colfax. Some of the original society buildings are now occupied by the Rocky Mountain College of Art and Design.

Hellion in the High Country (1899 and 1915)

Getting shot in the abdomen when you live in the high country could be fatal, even if the bullet didn't kill you right away. Shaffer's Crossing storekeeper Fred Wallace learned that the hard way.

Sheriff Joseph Dennis was called to Wallace's home in the wee hours of Saturday morning, July 17, 1915. He arrived with the local physician, Dr. Garvin, who said that he couldn't treat the wound without proper facilities. So they loaded a semiconscious Wallace into a horse-drawn wagon and made the long, jolting nighttime ride—eight miles of rutted dirt roads through the darkness of the mountains—from Shaffer's Crossing to the train station in Pine Grove. During this harrowing journey, Fred Wallace managed to tell the doctor and the sheriff his story.

Tensions had been building for some time, according to the victim—several years in fact. The trouble began when Fred and Emma Wallace moved with their children to Shaffer's Crossing from Lafayette, Colorado, and opened a small store. A local hellion named William Archibald Briscoe, Archie for short, quickly developed a taste for Emma Wallace, and the feeling was apparently mutual. But romantic trouble wasn't the only thing brewing amongst these folks—all three of them were overly fond of booze, and Fred and Archie had gone into the bootlegging business together.

A month before the shooting, law enforcement officers discovered the bootlegging outfit. Fred was arrested and fined sixty-five dollars. Archie somehow managed to avoid involvement, and Fred had been trying to get him to pitch in for the fine. The best Archie had come up with was ten dollars.

To make matters worse, according to Fred, Archie and Emma boozed it up together every time Fred left the house. He told his would-be rescuers:

A week ago, he [Briscoe] *took her away with him and they spent the night in Pine Grove. I went there Sunday morning and found him with my wife. I gave him a good beating, after he attempted to stab me with a large knife. I took my wife home with me and she agreed to keep away from Briscoe. He declared when I took his knife away from him he would "get me."* [6]

On the day before the shooting, Fred had gone down to Denver to buy vegetables. He returned home on Friday at about five o'clock in the afternoon. He saw Archie sitting on a neighbor's porch. Inside his house, he found Emma in bed, drunk. She admitted that she and Archie had been drinking whiskey all day.

Emma soon dragged herself out of bed and went to join Archie on the neighbor's porch. Fred marched over to fetch her home, but then all three inexplicably went back to the Wallace house and enjoyed some more drinks together.

After an evening of guzzling, some time about eleven o'clock Fred boldly decided that he'd had enough of Archie Briscoe and ordered him out of his

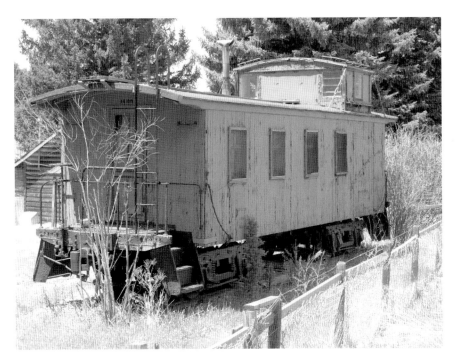

This charming caboose sits on display in Pine Grove. The village was once an important stop on the Denver, South Park and Pacific Railroad. *Photo by the author.*

house. Archie took off without a word. Ten minutes later, Fred left the house to feed the horses. Emma and the children watched from the doorway. A few moments later, Fred heard several shots and "felt a peculiar sensation" before falling to the ground.

Amazingly, Fred Wallace survived the wagon trip to Pine Grove, where they loaded him onto the first train to Denver. Later that day, he arrived at St. Anthony's hospital, where Dr. Garvin and Dr. William Scott operated on him. Unfortunately, the bullet had pierced his bladder, and he died at two o'clock on Saturday afternoon.

While the mortally wounded Fred Wallace was groaning out his story in the wagon, sheriff's deputies back at Shaffer's Crossing found Archie Briscoe passed out at the home of his mother, Mrs. Sarah Briscoe. As it turns out, just the day before, Mrs. Briscoe had warned Sheriff Dennis that there was going to be a killing.

Sheriff Dennis arrested Briscoe and brought him to jail in Golden. At first, Briscoe claimed that he couldn't remember anything because he'd been too drunk. Later on, he admitted shooting Wallace but protested that Wallace had been running around firing a gun and that he'd shot him in self-defense. Briscoe made a sober pronouncement on the subject of the shooting: "This is what wine and women bring to men. They are a bad combination."[7]

The inquest ruled that Wallace had been shot with felonious intent. Briscoe was handed over to the district court to face charges of murder.

Archie Briscoe's two-day trial was held the first week of November 1915 in Golden. His attorneys, Howard L. Honun and Arthur D. Quaintance, had tried unsuccessfully to get a change of venue. A mix-up occurred when the trial began, related to accommodations for the jury—the entire group ended up sleeping in cells at the new jail. "The bailiff, Chas. Judkins," the *Colorado Transcript* reported, "occupied the padded cell, and says he has been feeling a little crazy ever since."[8]

During the trial, Emma Wallace testified on behalf of her husband's killer, corroborating Briscoe's story that Fred had been shooting at him—not innocently feeding his horses as Fred claimed. She said that her husband had no reason to be jealous of Briscoe but that Fred was angry because Briscoe gave him only ten dollars to help pay for the sixty-five-dollar bootlegging fine.

Emma Wallace said that they'd "sat up" that evening until eleven o'clock. "The babies had started to cry and I went to the bedroom to take care of them,"[9] she said. While Emma tended to her babies, Fred ordered Briscoe out of the house. When Briscoe left, Fred followed him out with a gun and the shooting started.

When pressed by the prosecutor, Mrs. Wallace denied that Briscoe had threatened to take her away from Wallace and insisted that her husband had no reason to be jealous. The prosecutor tried to get her to change her story.

"Haven't you now a friendly feeling towards Briscoe?"

"I have no hard feeling against him."

"Isn't it a fact, Mrs. Wallace, that you want to see Briscoe get out of this trouble?"

"I have nothing to say," replied Mrs. Wallace.

Pressed for an answer, she said, "That is up to the jury."

"Well, how do you feel about it?" persisted the district attorney.

"I have nothing to say," answered Mrs. Wallace.[10]

Later, the D.A. pressed her again.

"Haven't you said on numerous occasions that you would testify for Briscoe if you had the opportunity?"

"I might have said that in fun."

"And you didn't mean it."

"No, sir."[11]

The district attorney suggested that Mrs. Wallace and Archie Briscoe had actually planned to run off together that night and that Briscoe had planted the murder weapon in a spot where he could get it easily. Mrs. Wallace admitted that the story Fred Wallace had told about her running off to Pine Grove with Archie Briscoe had been mostly true. However, she said that her husband had thrown her and her clothing out of the house and locked her out, saying that he didn't want her anymore. She continued to deny that she'd ever been intimate with Briscoe.

Archie Briscoe took the stand on his own behalf, telling a story similar to Mrs. Wallace's:

> *Wallace told me to get out. He followed me and began shooting at me. He said, "I have been intending to get you and I am going to get you now."*
>
> *I heard him following me and I went to where I had left my rifle leaning against the barn. I got the rifle. He fired at me and I shot at him. I never intended to kill him. I heard him call out that he had been shot and I went home and went to bed and waited for the sheriff to come and get me.*
>
> *Briscoe shed tears while telling his story.*[12]

Archie Briscoe's mother also testified on behalf of her son. Two months before, the sixty-three-year-old woman had taken time out from her son's troubles to elope with a local man named Anderson, so she was now called

Sarah Anderson. She tried to protect her son but was forced to admit that she had warned the sheriff about a possible killing in the works.

There was one important fact that forty-one-year-old Briscoe and his mother hoped folks would forget. Unfortunately for them, just about everyone in the region knew that Briscoe had killed a man once before.

Sixteen years earlier, back in 1899, Archie was a twenty-five-year-old who had been living for about three years with his parents in Pine Grove. Even back then, he was known as "noisy and quarrelsome."

On Tuesday night, May 30, 1899, Briscoe was drinking at the Pine Grove Saloon operated by an elderly gentleman named Thomas Crowdis. Crowdis was an old-timer in the region, well loved by the townsfolk. As he drank, Briscoe got more and more rambunctious, to the point where Crowdis asked him to leave. Briscoe refused, and Crowdis headed around the bar to make him do it. Briscoe struck the old man, but Crowdis was more agile than expected and quickly had Briscoe on his back on the floor. As soon as Crowdis let go, Briscoe jumped up and pulled a knife and stabbed Crowdis over and over in the heart. He kept the others at bay by swinging the knife around, ran out of the saloon and then went to hide at the home of his parents. Thomas Crowdis died about twenty minutes later.

Deputy Sheriff J.W. Green arrested Briscoe at home. He then made a nighttime dash out of Pine Grove, whisking his prisoner off to the jail in Golden before the gathering lynch mob could string him up in a tree.

The following week, a coroner's jury rendered its verdict:

> *We find that the said Thomas Crowdis came to his death on the 30th day of May, 1899, at about 6:15 o'clock p.m., at Pine Grove, Jefferson County, Colo., by ten knife stab wounds inflicted by a knife in the hands of Wm. Archibald Briscoe; and we further find that the said wounds were feloniously inflicted by said Briscoe upon the body of said Cowdis* [sic].[13]

Briscoe had his trial that November, at Thanksgiving time. A disappointed reporter wrote about the trial, which lasted only one day:

> *The trial of W.A. Briscoe on the charge of murder did not take up such a great amount of time after the jury had been secured. It was hard indeed to glean any information from the testimony, which was conflicting and in general struck the observer as being most unreliable. Thoughts of Thanksgiving dinners in the minds of the jurymen had much to do with the case, and after deliberating a short time they agreed to bring in a verdict of*

The pioneer cemetery in Pine Grove, where Briscoe's first victim, Thomas Crowdis, is buried in an unmarked grave. *Photo by the author.*

manslaughter. Had his trial been commenced four days later Briscoe would probably have been obliged to serve at least twenty years in the penitentiary, whereas he will get off with not exceeding five. Truly this young man will have cause to remember Thanksgiving, 1899.[14]

On December 3, 1899, Briscoe was sentenced to five years for the murder of Thomas Crowdis. After serving about a year, he was released on parole on December 28, 1900. The following year, he married a woman named Nellie Kidd and began working as a railroad tie maker. His sentence—considerably more lenient than the punishment friends of Thomas Crowdis had in mind—was discharged on August 24, 1903.

Twelve years later, he was single again (his wife Nellie had apparently died within the previous year or two) and once more facing a jury on charges of murder.

After two days of testimony in the Fred Wallace murder case, the jury found Briscoe guilty of voluntary manslaughter. Briscoe's attorneys wanted to file a motion for a new trial, but Briscoe himself decided against that. In meting out a sentence, the judge indicated that he was taking into consideration the fact that Wallace was also reportedly armed and shooting and that no one actually saw Briscoe shoot Wallace. Even Wallace himself before he died could not say he saw the shooter. The judge sentenced Briscoe to not less than one but no more than four years in the penitentiary.

In June 1916, Archie was working on a prison road gang in Weld County when guards caught wind of his elaborate plans for an escape. Archie was sent back to Cañon City. On September 5, 1919, the very lucky Archie Briscoe

```
9806 Archie Briscoe;
Recd 11-24-15; Jefferson Co.
4 to 5 years for Murder;
Age 41;wt 146;ht 5-9; Hat 7 1/4; Shoes 8;
Hair Black;Eyes Blue; Com.Ruddy;Build
Medium; Bust 38;waist 35;thigh 20; Neck
14 1/2; American/; Waiter;

Scar on both sides of front of head;
Scar back of head; 2 vac marks L.arm;
Scar L.Elbow; Hypo marks both arms;
Scar below L.Nipple; 2 scars outside R.
thigh; Lower teeth poor; Uppers false;
```

Archie Briscoe's Record of Convict. *Colorado State Archives.*

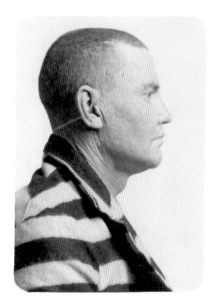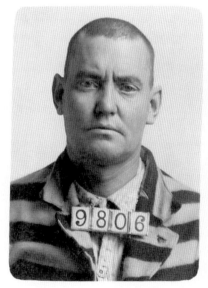

Briscoe's alluring qualities won him the loyalty of Mrs. Wallace. *Colorado State Archives.*

was released from prison after serving about four years for the murder of Fred Wallace. The 1920 census shows Archie living with his mother in the town of Marshall in Boulder County, where he worked as a farmer and coal miner. There is no mention of Sarah's husband, Mr. Anderson.

How Deadman Gulch Got its Name (1871-72)

O n a pleasant July Sunday in 1871, a camper hiking up a pretty gulch southwest of Golden City noticed something strange sticking out from a pile of rocks and timber. Upon taking a closer look, he discovered that it was a human hand.

The next day, Coroner Moore gathered up his jury and traveled to the spot, which was located near the head of the gulch. Lifting the rocks and timber, they found the rest of the body. In a state of extreme decay, the corpse had new clothing—"a black government overcoat, with brass government buttons, a thick black under-coat, thick vest and pants, and two heavy undershirts, showing that the deed had been committed in winter, or at least in cold weather. In the pockets were two or three new white handkerchiefs, folded nicely, and a pair of socks, but no papers or valuables of any kind."[15]

Someone had shot him in the back of the head.

Despite the lack of identification, several people remembered that inquiries had been made some months earlier for Mr. C.M. Thompson, who had gone missing the previous winter. The jury concluded that the body was probably Mr. Thompson, although there is no record that this identification was ever verified. There was no clue about who had murdered him.

The following spring, on a bright Saturday in May 1872, a group of railroad workers hiking down the same gulch found a second victim, also poorly hidden under a pile of rocks. This discovery was located only forty feet from where the other body had been found the summer before.

The coroner was not available, so Justice Allen brought a jury up to the spot to investigate. This fellow had two bullet holes in his head. Near the body they found an old jackknife and a "truss"—a term then used for a

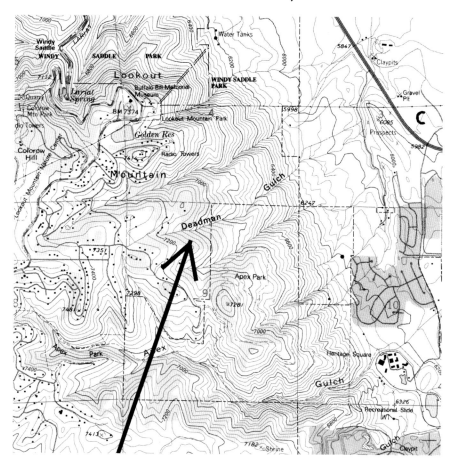

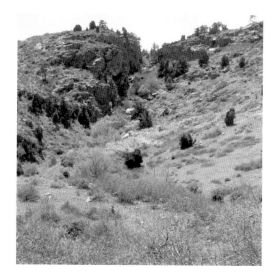

Above: Deadman Gulch is located just south of Lookout Mountain. *U.S. Geological Survey.* Golden Quadrangle [topographic]. *1:24,000. USGS 1994. The USGS Store: Map Locator. http://store.usgs.gov.*

Right: Deadman Gulch as it looks today. *Photo by the author.*

bundle or pack. As with the other body, there was no money on this man's person, nor anything else of value.

Investigators also discovered a couple of buttons farther up the gulch that matched buttons on his clothing. They concluded that the killer had shot the man at the top of the gulch and then dragged him down to the spot where they found him.

Both murders remain a mystery to this day, but the pretty little gulch had earned its name.

The Orchitic
Strangulator (1893)

On Sunday, November 26, 1893, at about four o'clock in the morning, Mrs. John McCurdy of Golden was awakened by a low moaning sound coming from the room of her stepson, eighteen-year-old Arthur Berry (or Albert Beery). She woke her husband, and the two of them hurried to Arthur's room, but something was blocking the door and they couldn't get in. They ran outside into the dark, got the window open and climbed into the room.

Inside, they found Arthur lying on the bed in a mass of blood. He seemed to be unconscious but was still moaning. There was so much blood that it took time for them to figure out what was wrong, but finally, with great horror, they realized that their boy had been castrated.

They summoned the doctor, who dressed the wound and did what he could to alleviate the young man's agony. Since Arthur had been lying in his bed and bleeding for some time, the blood loss was substantial and the doctor could not guarantee that he would pull through.

They found another injury on Arthur's head, indicating that someone had knocked him out with a blunt instrument before cutting him. Nearby, they found a simple table knife covered with blood. The blade had been ground down to a sharp edge.

Arthur eventually regained consciousness, and they asked him what happened. He said he couldn't remember anything except that someone had been in the room with him—his stepbrother, Alex McCurdy. Not surprisingly, thirty-four-year-old Alex McCurdy was nowhere to be found.

By later that day, Alex still had not made an appearance, which was odd since he lived there. Finally, the sheriff made out an arrest warrant for him, and they soon heard that he had been spotted in Denver.

Sheriff Samuel Poe and Constable Hendricks of Jefferson County traveled to Denver on the tram. Meanwhile, word spread through Jefferson County about the "nameless outrage," as the *Golden Globe* put it. An angry mob gathered at the tram stop near the courthouse, waiting for the officers to return from Denver with their man. Talk of a lynching circulated. Despite the depraved nature of the attack, the sentence for this particular crime was only one to three years in the penitentiary, and the mob didn't think that was punishment enough.

The McCurdys had lived in Golden for several years. Mr. and Mrs. McCurdy shared a house with Alex McCurdy, Arthur Berry and another younger brother named Delos McCurdy. Their small three-room home was located just north of the train roundhouse near the depot. Alex McCurdy was a stonemason, well known by everyone in town. The young victim, Arthur Berry, had worked for a time at the Church Brothers brickworks and then at a Denver Coal Company mine near Ralston Creek, north of Golden.

To the mob's great disappointment at the tram station, the deputies returned from Denver empty-handed. Meanwhile, young Arthur was in grave condition but still alive.

A month went by. Sheriff Poe had sent out details of McCurdy far and wide, without results. Then, on January 6, 1894, Sheriff Poe received a telegram:

> *MARTINSVILLE, IND, JAN 6.*
> *S.S. POE. GOLDEN, COLO:*
> *What reward is offered for McCurdy? Think have him located. Answer quick.*
> *CLAY MILLS, CITY MARSHALL*[16]

Sheriff Poe responded:

> *GOLDEN, COLO., JAN. 7.*
> *CLAY MILLS, MARTINSVILLE, IND.;*
> *No reward offered, but I will give $25.00. Don't arrest now unless you see he is going away. Watch until I get requisition. Answer quick.*[17]

And the same day, Sheriff Poe received a second telegram:

> *We have arrested and are holding him for you. Come and get him at once.*[18]

Sheriff Poe, after getting tangled up in some bureaucracy for a couple days, finally got hold of the requisition papers and set out for Indiana to

fetch Alex McCurdy. His term as sheriff expired as he journeyed east, so bringing in McCurdy was his final duty.

On Monday, January 22, 1894, the former fugitive stood before Justice Parshall in Golden. He waived examination and, unable to come up with the $1,000 bail, was sent to county jail to await the action of the grand jury. Once he was indicted, he managed to get his trial postponed until May 28 on the grounds that his wife was traveling back to Colorado to testify on his behalf.

The story soon emerged that, shortly before the attack, Alex McCurdy's wife had taken their young child and left her husband. She traveled back east to her family, with no intention of returning. McCurdy blamed Arthur Berry for this breakup, believing that there had been an intimate relationship between his wife and the teenaged Arthur. He had kept these suspicions to himself, remaining civil with his stepbrother. The knife attack on Arthur was the first anyone in the family knew there was a problem in that regard.

Arthur denied any relationship with his stepbrother's wife.

When McCurdy finally went on trial, he and his lawyer, Charles M. Bice of Denver, claimed a defense of temporary insanity. The *Golden Globe* refused to give much information about the trial, explaining that "the details of the trial are rather too loud for these columns" but that the "usual number of bald heads listened to the salacious testimony."[19] The *Colorado Transcript*, referring to the defendant as the "orchitic strangulator,"[20] also provided a minimum of details.

The defense made the case that Arthur had had a love affair with Alex's wife and that this affair drove Alex insane. McCurdy admitted to climbing through Arthur's window on a cold winter's night, bashing Arthur's head with a club and then castrating his stepbrother. His wife testified in his defense, claiming under oath that young Arthur had been intimate with her.

On Wednesday, May 30, 1894, Alex McCurdy was convicted of the crime of "mayhem" and sentenced to three years in the penitentiary.

To the great surprise of no one, in the wee hours of Saturday morning, June 2, a band of masked men appeared at the Golden jailhouse. They forced their way in and tied up Undersheriff Alexander Kerr (the father of future sheriff Gary Kerr). They snatched Alex McCurdy out of his cell and dragged him off to the new Lakewood extension bridge over Clear Creek, near the Cambria Fire Brick Works (in the vicinity of today's Ford and Tenth Streets).

Undersheriff Kerr managed to wriggle out of his bonds and hurried to notify the new sheriff, George Kelley. By the time Sheriff Kelley reached

the bridge, the mob had taken their gruesome revenge: ignoring their prisoner's pleas, they stripped Alex McCurdy, castrated him and hung him from the trestle.

For some reason, two men still remained at the scene, watching over the nude, mutilated and dangling body. Sheriff Kelley arrested both of them—John Richweine and John Koch. These two quickly divulged the names of their comrades. The sheriff then swore out warrants for the entire mob. However, as was often the case, there are no records of a trial or prison sentence for those involved in the lynching.

Since the entire situation had understandably become too much to bear for the rest of the McCurdy family, they left town. The *Golden Globe* pointed out that Arthur Berry had not been with the mob. A rumor circulated that Alex McCurdy's widow was suing Jefferson County for $25,000 for the loss of her husband, even though she had already left him.

At least one imaginative writer for the *Globe* later reported that he had seen "the ghost of Alex McCurdy prowling around the bridge from which his body was swung."[21]

Love Triangle at Sherie's Ranch (1923)

About nine o'clock on a crisp fall morning, October 23, 1923, Mr. A. Carmichael walked over to his neighbor's farm to let him know that his cattle were running loose. As he approached the farmhouse, located on the Golden Road near today's intersection of Simms and West Colfax, he noticed something strange lying in the weeds in front of the house. As he crept closer, he saw that it was the bloody, half-nude body of a woman.

In shock, he ran toward the house, where he found another body on the porch—his neighbor, Andrew Sherie, clad only in his undershorts.

When Coroner Weeks and Sheriff Gary Kerr arrived, they found a bloody mess inside the house, as though a violent struggle had taken place. As they investigated the premises, Denver's assistant fire chief, William S. Bryan, drove up to the ranch house. He said that his wife had been missing all night and that he had come to see if his good friend Andrew Sherie knew where she might be. The officers pointed out the woman's body in the weeds. She was Bryan's wife, thirty-six-year-old Georgia A. Bryan.

The dead man, Andrew Sherie, was a longtime resident of the region and an old family friend of Mr. and Mrs. Bryan's. Sherie had also known Georgia's family for many years. Although Sheriff Kerr was shocked to find the assistant fire chief's wife half naked and dead in the weeds in front of the Sherie ranch house, he had not been surprised at being called there. He had been to Sherie's before and had even searched the place twice. Andrew Sherie was suspected of being a bootlegger.

Three years earlier, in 1920, the U.S. Congress enacted the Eighteenth Amendment to the Constitution. Also known as the Prohibition Act, the new law made it illegal to manufacture, sell or transport intoxicating liquors. Colorado

had already enacted its own prohibition law back in January of 1916. The laws did not exactly sober up the nation. "Speakeasies" popped up everywhere, half the citizens and their cousins cobbled together secret breweries hidden in shacks and basements and mobsters waged gang wars to gain control of the incredibly profitable business of illegal alcohol. The local newspapers at the time were full of Sheriff Kerr busting farms and ranches for illegal stills.

At the ranch house, Andrew Sherie and Georgia Bryan had each been shot three times. The bed was soaked in blood, and the floor of the bedroom was covered with bloody footprints—identified as those of Andrew Sherie. Mrs. Bryan had great cuts on both of her arms, and her left arm was broken at the elbow, probably from having been twisted. Her face and neck showed considerable powder burns.

Authorities speculated that Sherie had been shot first but that the bullet did not kill him. The shooter then dragged Georgia Bryan from the bedroom and out onto the porch. She managed to wrench herself free, possibly breaking her arm in the process. She lurched out into the weeds, but the killer shot her three times at close range—in the shoulder, the back and through the torso. Meanwhile, Sherie managed to get out of bed and stagger from the room. He grappled with the killer before making his way out onto the porch, where the killer finished him off.

Though investigators must have been eyeing the husband, William Bryan, as a suspect, the case soon took a sudden turn in a different direction. The same day the bodies were discovered, a man named Arthur H. Mitchell walked into a Denver police station and confessed to the murders.

Mitchell was a farmer and had been in trouble with the law before. A year earlier, he had run over a man while driving his car. Though he killed the fellow, his punishment was only a month in jail and a fifty-dollar fine. A week before the Sherie's ranch killings, he had been released from jail after serving another thirty days for drunkenness and reckless driving.

In his confession, Mitchell blurted out that he had been in love with Georgia Bryan for eight months, though she did not return his devotion. On the day of the killing, Monday evening, he and Mrs. Bryan were drinking whiskey together when they decided to drive out to Golden to visit her friend, Andrew Sherie. At Sherie's ranch, the three began a drinking party, at which Georgia became intoxicated. Mitchell said that she "began to tear her clothes off," and before he could put a stop to it, she had disappeared into the bedroom with Andrew Sherie.

The jealous Mitchell grabbed Mrs. Bryan's black suede pumps and her blue dress, left the ranch house and drove back to Denver. He had stolen her

clothes to prevent her from leaving Sherie's place. In Denver, he put Georgia's dress and shoes into an ash pit at 2455 Thirty-seventh Avenue. Next, he got hold of his handy Colt .44 revolver and headed back out to the ranch.

When he arrived, Mrs. Bryan and Mr. Sherie were still in the bedroom. He went into the room, pointed the revolver and began shooting. Mitchell claimed that they both got up from the bed and staggered out into the yard on their own, which didn't explain Mrs. Bryan's broken arm and cuts nor the mess in the house.

After murdering the pair, Mitchell drove back along the Golden road (today's South Golden Road and West Colfax). At some point, he wrecked his car. He wandered around in a daze and, several hours later, appeared at the front door of his ex-wife, Barbara Mitchell. He told her what he'd done. Barbara called her pastor, Reverend W.C. Garberson of the Mount Hermon Baptist Church, who rushed over. The two of them persuaded Mitchell to give himself up. They escorted him to the nearest police station, where he confessed. He then directed officers to a location near Edgewater where he had stashed his gun.

Mr. Bryan, along with Georgia Bryan's parents, adamantly insisted that Georgia was a good and faithful wife and mother. Not only that, but Andrew Sherie was a beloved friend of the family who would never do such a terrible thing. Mr. Bryan said, "Andy Sherie was my best friend as he was the best friend of my wife's people. He was just like a brother to all of us and I know that he was a true friend no matter what that cur Mitchell says to the contrary."[22]

Mr. and Mrs. Bryan were married in 1907 in Fremont County and had a fifteen-year-old daughter named Grace. Three weeks earlier, they had celebrated their sixteenth wedding anniversary.

Two days later, on Thursday, Coroner Woods held an inquest over the two murder victims. Many of the victims' family members were present, including two sisters of Andrew Sherie who had come down from Casper, Wyoming. William Bryan identified the black suede shoes and blue dress that police had pulled from the ash pit on Thirty-seventh Avenue. After Mitchell's confession was read to the jury, no one was surprised when the verdict was death by gunshot wounds inflicted by Mitchell.

In the early days of the case, District Attorney W.L. Boatright stated that because there was no surviving witness to the crime, Mitchell could not be given a death sentence unless he reiterated his confession on the stand. The maximum he could get would be life in prison. This may have inspired Mitchell's response when he was brought before Judge Samuel W. Johnson on Saturday, October 27 to enter his plea. He hung his head and said nothing.

He was following the instructions of his new attorneys, Herbert Munroe and S.D. Crump, who had been hired by the same ex-wife who had convinced Mitchell to confess.

Attorney Munroe then asked for a continuance (delay) to allow him time to investigate the case. Mitchell later entered a plea of not guilty by reason of "insanity induced by his indulgence in moonshine whiskey."[23] The trial date was set for December 3.

A story circulated that Mitchell's attorneys had originally planned to have him plead guilty until D.A. Boatright decided to risk asking for the death penalty. This was a first—asking for capital punishment with only circumstantial evidence. The district attorney's plan was to try Mitchell on one of the murders first. If that case did not result in a conviction, they would try the second case asking only for a life sentence. In view of Mitchell's previous confession, which they had in writing, the district attorney felt they had him cornered.

Meanwhile, Arthur Mitchell enjoyed the aid and comfort of his loyal ex-wife. She sold her house and possessions to pay for his attorneys and stood by him during the entire ordeal. Born Barbara Conrad, she had married Arthur Mitchell back in 1891, thirty-two years before the murders. (The date of their divorce is not on file with the Colorado archives.) The couple lived in Florida before moving to Colorado some time between 1900 and 1910. The 1920 census indicates that the Mitchells had a son named Edwin R. Mitchell, born in Colorado in 1911. During the trial, Barbara expressed a willingness to remarry Mitchell if it would help—since a wife could not be forced to testify against her husband.

Mitchell's trial for the murder of Georgia Bryan began Monday, December 10, 1923. Arthur Mitchell, who previously seemed calm and composed, was now obviously agitated. His faithful and now homeless ex-wife sat next to him in the courtroom.

During a lengthy jury selection process, the prosecution dismissed all prospective jurors who expressed opposition to capital punishment. When the judge realized the trial would probably take some time, he also called for a thirteenth juror to serve as a possible replacement if the need arose.

The members of the defense revealed some of their cards when they asked the following question of prospective jurors: "If the evidence shows that the woman who was one of the victims deliberately furnished this man with whiskey to induce him to accompany her to a disorderly house for the purpose of breaking the law, would you take these facts into consideration?"[24]

Once the trial got rolling, the defense tried to get Mitchell's confession thrown out on the grounds that it was made to the pastor, Reverend Garberson, and that it was therefore privileged information. The prosecution argued that the confession to the reverend was made in the presence of Barbara Mitchell, which took it out of the category of privileged. They pointed out that Mitchell also confessed to officers after arriving at the police station. The defense countered that Mitchell was still "crazy drunk on whiskey" and that his confessions were simply drunken ravings. Not only that, they said, when he confessed to the police he was also under the influence of religious fervor.

The judge ruled that the confessions were admissible, and Barbara Mitchell did testify about what her ex-husband had told her.

In their summation, the prosecution questioned how Mitchell could be considered insane:

> *It is impossible to believe that a man who did the things this man did is crazy. When he became jealous of Sherie's attentions to Mrs. Bryan at the Sherie ranch, did he act like a crazy man? The facts in the case do not show this. The facts show that he stole Mrs. Bryan's clothes so he could be sure she would be there when he came back to perpetrate his foul deed. Would a crazy man have done this?*
>
> *Then the defendant drove to Denver, hid Mrs. Bryan's clothes in an ashpit and got his gun. Then he drove about six miles, and murdered the man who had ignored his protests and the woman who had given herself to another in his presence.*
>
> *These things show careful planning. They do not show that the defendant acted blindly as a crazy man might act. Mitchell was enraged with jealousy, he was maddened by moonshine, but he was not crazy. He displayed devilish cunning in all his actions. He stole up to the Sherie ranch house to do what he had decided to do as a stealthy animal would have stolen upon its prey.*
>
> *Mitchell showed calmness after the shooting when he carefully hid his gun and covered up his tracks in making his getaway. Undoubtedly Mitchell was drunk, but he was not crazy. If a man can claim immunity for a foul deed because he has taken a few drinks of bad whiskey—what is society coming to?* [25]

The case went to the jury on Saturday at 8:15 p.m. The judge instructed jurors that they could arrive at verdicts of first- or second-degree murder, manslaughter, justifiable homicide or acquittal. He also told them that they could not take into consideration any promises that Barbara Mitchell had made

to her ex-husband in order to induce him to confess—such as a lighter sentence. He discussed the issue of insanity and to what degree intoxication could make one "insane"—that is, how drunk one would have to be in order for it to "affect the condition of the mind."[26] He told the jury that if Mitchell was too drunk to premeditate the murder, he could not be held guilty of first-degree murder.

The members of the jury deliberated for only two hours, and at 10:45 p.m., during a special night session at court, they announced that they had reached a verdict.

Both Mitchell and his ex-wife sat quietly while the verdict was read: guilty of first-degree murder with a penalty of death.

Jurors later said that all agreed on his guilt during the first ballot but that three holdouts felt that he should get life imprisonment. It took a couple of hours to bring them around.

The verdict was significant in the history of Colorado jurisprudence as the first time a death penalty was secured using circumstantial evidence.

Mitchell's attorneys immediately asked for and were granted a fifteen-day period during which to prepare a petition for a new trial. If such a petition were denied, Judge Johnson would name the week of Mitchell's hanging. The defense indicated that it would take the case all the way to the Colorado Supreme Court if necessary. It felt that it had a good chance since it was the first trial in Colorado history where a death penalty was imposed without a witness. The prosecution insisted that Mitchell's three confessions served as ample substitute to witnesses.

On December 29, 1923, defense attorneys Munroe and Crump filed a motion for a new trial on the grounds that both the verdict and penalty were contrary to law and evidence. Their motion claimed that the confession Mitchell gave at the police station should not be admitted as evidence because he gave it at the urging of a pastor and because the pastor had told him a confession would result in a lighter sentence. They also complained about several technical errors in the instructions given to the jury.

The hearing on this motion was January 12, 1924, at which time Judge Johnson overruled the motion. While he was at it, he sentenced Mitchell to hang during the week of March 18–24. Counsel Crump applied for and was granted a sixty-day stay of execution, which would allow them to file for an appeal from the Colorado Supreme Court. Mitchell's hanging was then set for the week of May 18–24.

As he listened to the judge, Mitchell was so disturbed that he had trouble standing. When asked if he had any statement to make, he whispered, "I have nothing to say."

Mitchell's would-be savior and long-suffering ex later gave reporters a hint of their newest strategy:

> *I have changed my mind completely. I thought at first that Arthur had done it, but I was sure he was not in his right mind. Now, I am convinced that he is entirely innocent. I think that he went back to the Sherie ranch that night, as he says, but I believe that when he arrived there he found Sherie and Mrs. Bryan both dead. Arthur was so drunk he didn't know what he was doing and I think that is why he came and told me that he had killed them.*
>
> *I am sorry I ever advised him to go to the police and confess. If I had it to do over again I certainly wouldn't do such a thing. I am sorry I went on the witness stand and told what he had told me.*[27]

Mrs. Mitchell went on to say that she intended to move to Cañon City to be near him until the end and that she would somehow find work there. "He is all I have left, and I am all he has," she said.[28]

William Bryan, his daughter, and Georgia Bryan's mother and sisters were also in the courtroom but did not make a statement to the press.

Mitchell still had to face trial for the murder of Andrew Sherie. This trial was postponed until the Colorado Supreme Court ruled on his appeal, which took nearly a year.

While he waited, Mitchell was kept in the Golden jail. He became a model prisoner and earned the rights of a trusty, working around the courthouse and jail. Reporters described him as "quiet, gentlemanly and accommodating," and he made "numerous friends around the courthouse."[29]

In December 1924, the Colorado Supreme Court finally reviewed Mitchell's case. The court decreed that in March 1925, Arthur Mitchell must go to the gallows.

Although Mitchell had not expected this ruling, this time he managed to say something: "I am ready to die, if the law demands it, but it really looks as though I had been given the worst of it when one considers that Brindisi, Jannsen, and others who have been convicted of murder recently have not been given the death penalty."[30]

Mitchell's lawyers indicated they would now seek the last resort in all such cases—a commutation of his sentence to life imprisonment from the governor. Many of Mitchell's new friends around the courthouse signed a petition for commutation, including a number of law enforcement officials.

In January 1925, Mitchell said emotional goodbyes to all of his friends and supporters. With a smile, he told them, "I am satisfied—satisfied that

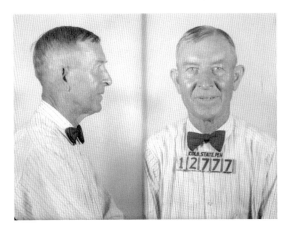

The congenial Arthur Mitchell, with a body count of three, made many friends during his stint in the Golden jail. *Colorado State Archives.*

Governor Morley fully understands the circumstances of the case and he will commute the sentence."[31]

Sheriff Walter Johnson escorted Mitchell to Cañon City, where he was put into a "death cell." There, he awaited his execution, scheduled for the week of March 16, 1925. The sheriff later told reporters that, as they drove out of Golden, Mitchell leaned forward and gazed at a ranch house a short distance from the road. This was the Sherie house, where the two shooting victims had died a year and a half earlier.

During his incarceration in the Golden jail, Mitchell had concluded that his alcoholic fog had prevented him from remembering the truth about what happened that night. As they drove to Cañon City, he told Sheriff Johnson an entirely new version of events:

> *To tell you the truth, I don't remember distinctly a single thing about the killing of Georgia Bryan and Andy Sherie. I don't remember making the confession, which was the basis of my death sentence.*
>
> *I was in a drunken stupor at the time of the shooting. My memory won't function concerning the happenings of that night and the day after. Ever since, while I was confined in the jail at Golden, I tried to pierce the veil which clouds my memory, seeking to recreate the picture of what happened in that house on the Golden Road. I felt helpless, like a person groping about in a fog.*
>
> *But out of all my mental gropings a vague picture has been evolved in my mind. I can't explain it exactly, but I believe it is the true picture of what happened during that dreadful night. I cannot describe it better than to compare it with an old and dim motion picture film, scratched and blurred, with here and there a gap where a portion of the film is missing.*

Here is what I see in the picture: A drunken party, with all three of us, Georgia, Andy and I, hilarious from the effects of much moonshine. Presently I tell Georgia that the party has gone the limit; that it is time for us to go home. But she laughs and cries out that the party has just begun.

Then, believing that I have hit on a plan to make her leave Sherie's house with me, I take her clothes and leave—so the picture seems. I believe she must follow me to get her clothes—that this will compel her to leave Sherie.

I can see myself driving back to Denver. Finally I realize that she has not followed me. I speed back to the house on the Golden road, hoping to induce her to leave.

Then flashes on the screen of memory the scene when I returned to the bungalow. I see myself pleading with them. My plans are successful. She prepares to go.

Then Sherie becomes angered because she is leaving him to go with me. He staggered into the back room. A moment later there is a spurt of fire in the darkness and Georgia screams. She runs out of the door. Sherie shoots again.

Then it seems from the picture, I fly into a jealous rage. I draw forth my pistol and blaze away at Sherie.

Then the film snaps.

The next I remember is in the Denver jail. I can recall this clearly, without effort, without groping. I remember reading in the newspapers that I had confessed killing both Georgia and Sherie.[32]

Sheriff Johnson did not indicate to reporters whether or not he believed this story.

In the middle of March 1925, Governor Clarence J. Morley granted a two-week reprieve to Arthur Mitchell for the purpose of "personal inquiry," telling the warden at Cañon City to postpone the hanging until the week of April 6. In the coming months, Governor Morley would grant three additional reprieves to Arthur Mitchell, the latest directing his execution for the week beginning August 10, 1925. And finally, during that week, Governor Morley commuted Mitchell's sentence from hanging to life imprisonment.

There is no record of Mitchell standing trial for the murder of Andrew Sherie. He spent the rest of his life in prison.

Census records for 1930 show Barbara Mitchell working as a servant for a private family in Denver and living with her nineteen-year-old son, who worked at a filling station. Her son was no longer called Edwin R. Mitchell but rather went by the name Raymond Loceby.

The Mystery of the Winter Camper (1921)

It was a bleak midwinter in 1921 when Mrs. S.S. Yamaguchi of Denver began to lose hope that authorities would ever find her husband.

Several months had passed since the wealthy Denverite Mr. S.S. Yamaguchi had packed a few tents and other gear into his Ford and headed up to Genesee Mountain, seeking health and solitude. Mr. Yamaguchi had long suffered from tuberculosis, and he hoped that camping out in the high altitude and fresh air might improve his condition.

His wife remained at their Denver home, and they stayed in touch through letters. She occasionally drove up to visit her husband. The last time she had seen him was December 3, when she had visited his camp. She next received a letter from him dated January 4. By the end of January, several weeks had passed without a letter, so she drove up again to visit his small camp on the south side of the mountain. What she found was a blank spot—his Ford, tents and all his belongings had vanished.

Mrs. Yamaguchi, described as a "demure little Japanese woman," rushed to notify the sheriff's office. For the next month, teams under Jefferson County sheriff Gary C. Kerr and Captain Orville Dennis of the Colorado State Rangers (the son of former sheriff Joseph Dennis) fruitlessly searched the snowbound regions around Genesee Mountain.

During this period, an abandoned Ford was found hidden under a clump of willows in the game preserve on Genesee Mountain. The fellow who found it—Lucian Ralston, from a prominent local family—had heard nothing of Mr. Yamaguchi's disappearance and assumed that the car had been stolen and abandoned. When he returned to the spot the next morning, the Ford had vanished.

During the search for Mr. Yamaguchi, Sheriff Kerr questioned two young local teenagers—Sam Franklin and Charles Ferguson. The previous year, when Sam Franklin was eighteen, he had been arrested for breaking into a well-appointed summer house up on Lookout Mountain. He spent the night in the home and helped himself to whatever items caught his fancy. The next morning, he was beset by an irresistible urge to burn the place down. In his enthusiastic rush to get the fire going, he forgot to figure out an escape route, and before he could make his way out of the flame-engulfed home, he was severely burned himself. The judge and everyone else involved felt sorry for the hapless lad and let him off without further punishment.

In the case of Mr. Yamaguchi's disappearance, Franklin and his friend Ferguson had been heard talking about the winter camper, but when questioned, they denied knowing anything about him. The sheriff briefly arrested the boys but later released them for lack of evidence.

Meanwhile, search parties of twenty or more tramped through snowy ravines, crept into old mine tunnels and searched down abandoned mine shafts and wells to no avail. Several skeptical officers suggested that Mr. Yamaguchi might be a notorious poacher known to prey on the buffalo and elk that lived in the game preserve. They figured that "the Jap" had probably fled the area when he thought his poaching activities had been discovered.

In late February, after more than a month of frustration, Captain Dennis announced that he was suspending the search.

The "demure" Mrs. Yamaguchi, however, did not give up. She hired a private investigator, Charles Björk. She and Björk spoke to people who lived in the area where her husband had been camping. The mother of one of the boys who had been questioned by the sheriff, Mrs. Ferguson, said that she'd heard that Mr. Yamaguchi had taken off for California. Another witness told them that Sam Franklin was the one spreading the California story. Several people reported that a "Hoquist boy" had seen Mr. Yamaguchi breaking camp.

On March 24, a Denver high school student, B.J. Hinman, discovered the mysterious Ford once again—this time at the bottom of a cliff below Colorow Point on Lookout Mountain. Someone had cut a wire fence and pushed the car off the cliff. The student jotted down the engine number and somehow found out that it belonged to Mr. Yamaguchi. Instead of notifying the sheriff, he contacted Mrs. Yamaguchi and Charles Björk, who hauled the car back to Denver. The wrecked car did not give away any secrets about the fate of Mr. Yamaguchi, except to create serious doubt about the California story.

On Sunday, April 12, three months after Mr. Yamaguchi's disappearance, the warm spring sun had melted the snows choking the mountains, and the rushing waters of Clear Creek offered up another clue to the Yamaguchi mystery. The foreman who manned the Beaver Brook railroad station in Clear Creek Canyon, located near the spot where Beaver Brook runs into Clear Creek, noticed something lodged on a large boulder in the creek. Looking more closely, he realized with much consternation that it was a human body.

Investigators soon arrived and retrieved the body from the river. It was so severely decomposed that the head was nearly detached. There was no clothing and very little flesh left, which gave the detectives an instant view of the event that had ended the person's life: a bullet hole in the skull.

It did not take them long to suspect whose body they had found. Mrs. Yamaguchi was called in, and after drumming up the courage to view the remains, she positively identified her husband. She said that the teeth matched his, along with the shape of the head. She also pointed out a deformed toe that matched the same on her husband.

Coroner William Woods held an inquest, and the jury determined without much debate that Mr. Yamaguchi had been murdered. Yamaguchi's dentist, Dr. Miyamoto, confirmed the identification by matching the teeth on the corpse to his client's dental records.

A local criminologist, Dr. Albert L. Bennett, was employed to examine the remains. He testified that the jagged wound at the top of the skull had clearly been made by a bullet and that the jawbone had also been damaged. Extrapolating the path of the bullet, he surmised that Yamaguchi was lying down when he was shot. He ruled out a suicide because the top of the mouth—the hard palate—was still intact, so the injuries did not come from a muzzle inside the mouth. He also said that the bullet may not have killed Yamaguchi. The victim had probably risen after being shot and was then given a fatal blow with a blunt instrument.

During the inquest, a local boy named Teddy Freisleben said that he'd seen Mr. Yamaguchi in his camp as late as January 12. He later noticed that the man had gone, but he assumed that the cold had driven Mr. Yamaguchi back home to Denver. He repeated the story that the young firebug Sam Franklin had told him that "the Jap" had gone to California.

Sam Franklin and Charles Ferguson also testified. Sam at first stated that he noticed on January 5 that one of Yamaguchi's tents had been taken down. A short while later, during the same testimony, he changed the date from January 5 to January 25. Still later, he changed it back again. When

questioned about his shifting story, he said that he could not remember the dates. He testified that Yamaguchi had told him that he was planning to go to California or to Estes Park.

The other boy, Charles Ferguson, denied any knowledge of Mr. Yamaguchi's disappearance.

About a week later, the case took another strange twist when searchers discovered a cap on the banks of Beaver Brook, near the spot where Mr. Yamaguchi was found. The criminologist Dr. Bennett inspected the cap and found a diamond sewn into the lining. Rumors flew wildly that the diamond was at the heart of this mysterious murder, but Mrs. Yamaguchi insisted that neither the diamond nor the cap belonged to her husband. Eventually, a Colorado School of Mines student came forward and claimed the cap, saying that he had lost it while hiking during the winter.

Meanwhile, the industrious young Genesee Park boys and their families, the Franklins and Fergusons, hired a well-known local attorney, Arthur D. Quaintance, who filed a suit against the sheriff's office for false imprisonment, referring to their initial arrest early on in the case. They also filed suit against Charles Björk, Mrs. Yamaguchi's private detective. Each suit claimed $50,000, for a grand total of $200,000 worth of damages (several millions in today's dollars).

On Monday, May 9, the Colorado State Rangers found a pair of field glasses in the possession of nineteen-year-old Sam Franklin. Mrs. Yamaguchi identified the glasses as belonging to her husband. Captain Dennis of the rangers rearrested Franklin, charging him with grand larceny for the theft of the glasses. Dennis stated that other items of interest had been found with Franklin, but he declined to elaborate.

Franklin's attorney, Arthur Quaintance, made sensational statements to the press, saying that he believed that the entire case was an instance of insurance fraud, that the body found was not Mr. Yamaguchi at all. He claimed that he had requested permission to take photographs of the body in case the charges against his client developed into murder charges. He complained that he'd been denied permission to take the photographs and that the body had been rushed away and cremated. Coroner Woods denied that Quaintance had ever asked permission to photograph the body and stated further that not only had the dentist, Dr. Miyamoto, positively identified the remains as those of Mr. Yamaguchi, there was also no life insurance policy on the victim. Woods accused Quaintance of inventing the story.

Mrs. Yamaguchi substantiated the coroner's claims, saying that her husband had been unable to purchase life insurance because of his tuberculosis.

Franklin had a preliminary hearing on May 28 during which the teenager pled not guilty to grand larceny. After hearing the case, Justice of the Peace Lewis ruled that there was sufficient evidence that the field glasses had belonged to Mr. Yamaguchi, and the case was bound over to the district court for trial.

The two-day trial took place in December 1921. At that time, Quaintance was able to prove that Franklin purchased the field glasses himself through a mail-order house. Franklin was acquitted and released.

In January 1922, the two $50,000 damage suits against Sheriff Kerr brought by Sam Franklin and Charles Ferguson were dismissed. The suits against Detective Björk were still standing.

The saga of young Sam Franklin continued the following month when he was arrested once again. This time, he was caught burglarizing the Boy Scout cabin on Beaver Brook—not far from the spot where Mr. Yamaguchi's body was found. Once again, his father managed to get him off the hook by promising the court that he'd send the boy out of state.

Charles Franklin gave his son some money and sent him away, but Sam had other ideas. He used the money to buy an old car and embarked on a crime spree—breaking into a series of summer homes and cars. For good measure, he stole $150 from his long-suffering father's own stash, which the elder Franklin kept in a fruit jar. Sheriff Kerr, formerly the target of the wrongful arrest lawsuit, arrested Sam Franklin again. Sam confessed to stealing phonographs, lap robes, Kodaks, shoes, overcoats and whatever else he could get his hands on. He also stole gasoline for his car from the Duvall-Davison Lumber Company.

This time, Sheriff Kerr himself escorted the lad across the state to the reformatory at Buena Vista—and left him there.

The nimble Sam got himself paroled quickly from Buena Vista, but his days of freedom were numbered. In January 1924, at least a dozen mountain cottages in the Evergreen area were burglarized. Sheriff Kerr and a couple deputies from Morrison headed into the mountains looking for the culprit. Before long, they spotted an automobile parked near a cabin. Suspicious about the car, they decided to have a closer look. As they moved in, a man darted out of the cabin's back door. He made it out to the road and to the parked car and then jumped in and took off with the officers in pursuit. The fleeing car soon became stranded in a snowdrift near Cub Creek, southwest of Evergreen. The deputies followed their target's footprints through the snow up to another cabin. As they approached, the man ran out of the cabin, huddled behind a rock and threatened to shoot. The officers fired into the air, at which point the fellow surrendered.

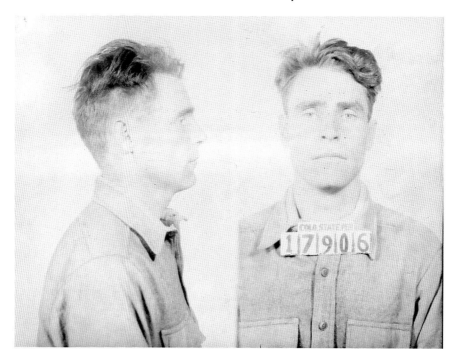

Sam Franklin started young in his life of crime and had a long career. *Colorado State Archives.*

Sam Franklin was still on parole from his previous crimes when he was charged with looting the cottages and stealing the car in Boulder County. At his trial, his attorney's motion for a new trial was overruled, and Franklin was sentenced to eight to ten years in the penitentiary. On April 2, 1924, he was received at Cañon City to begin serving his sentence. On September 6, 1926, he escaped while working on a road crew near Pueblo but was caught the same day and returned to prison.

Released from prison in 1929, Sam made efforts to work as a farmer but in 1934 was back in prison for burglary on another eight- to ten-year sentence. Paroled again after three years, he stayed out of trouble for another seven years. In 1944, at the age of forty-two, Franklin was back in prison for larceny on a sentence of three to ten years. He was paroled yet again in 1946 and discharged in 1950.

Although investigators on the case never stopped believing that Sam Franklin was involved in the murder of S.S. Yamaguchi or at least knew who did it, the case was never solved.

Murder on Table Mountain (1910)

In the late summer of 1910, a fifty-nine-year-old Denver woman named Maria Laguardia vanished. An 1890 immigrant from Italy, she had married Michael Laguardia in 1875. The couple had no children, but Maria was close to other family members in the area.

Maria was known to carry hundreds of dollars stashed throughout the folds of her clothing, and her worried nephew and niece thought she might have been the target of a robbery. They contacted Mrs. Laguardia's "goddaughter," Angelina Garramone, who, along with two other women, was the last person seen with Maria. Angelina assured them that Maria Laguardia was alive and well and had simply gone off to meet her long-lost husband. Sixteen years earlier, Michael Laguardia had also disappeared after getting into some "trouble" involving a young girl.

Family members were skeptical and did not trust Angelina Garramone. Though the 1910 census lists Angelina's husband, Luigo (or Louis) Garramone, as a "huckster" (a vegetable peddler) and her occupation as "none," she was by all accounts a prominent and notorious figure in Denver's Italian community. Thirty-five-year-old Angelina was a small woman at five foot two and 110 pounds. Although she later claimed that she had lost six children, she had six living children, including a boy at the reform school (called the Industrial School) in Golden. She had recently moved out of her family home and taken her own room. The central figure in a series of real estate deals, she had allegedly erected more than a dozen buildings in Denver. Some of these deals had gone bad. Recently arrested and tried for forgery and uttering (cashing a forged check), she was expected to be given a significant term in prison. Meanwhile, people still called her the "Queen of Little Italy."

She was also considered a witch and a soothsayer, and folks were afraid of her. Angelina Garramone had many enemies in the Italian community.

Eventually, Maria's family contacted police, but the investigation went nowhere.

About a month later, another woman from the "Italian Colony" disappeared. Mrs. Dorinto Labata had been living as a wife with a man named Clemento Cellanto when she vanished. Her body was soon found in a ditch in Adams County, her throat sliced from ear to ear. Authorities suspected Clemento Cellanto, but he had a different story to tell. He said that Mrs. Labata was a partner of Angelina Garramone's and that, shortly before Mrs. Labata disappeared, the two women had a falling out and dissolved their partnership. Cellanto told police that Angelina had been in their home visiting with Mrs. Labata on the day the latter disappeared. Cellanto went out for a while, and when he returned, his "wife" was gone. Angelina told him that Mrs. Labata had gone to visit someone in north Denver. She told police she had no idea what happened to Mrs. Labata.

In January 1911, Angelina was sentenced to five to eight years on her forgery case. She was taken to Cañon City to begin serving her sentence.

Seven months later, on August 1, 1911, a young Golden rancher named J.M. Johnson Jr. was up on South Table Mountain, which was part of the Johnson property. Peering down into a gulch, he noticed a bit of blue calico peeking out from among the weeds. Something about it didn't look right, so he crept down the gulch and had a closer look. To his horror, he realized that the blue calico was part of a woman's skirt and below that material were the remains of a pair of human legs. The shoes were still on the feet. Nearby lay a piece of skull and several ribs.

Investigators who closed in on the Johnson ranch surmised that the body had been hastily buried in the gulch at least a year earlier. The rainstorms that spring had washed away the dirt covering South Table Mountain's grim secret.

Based on the shoes and the tattered bits of clothing, the victim's niece and nephew identified the remains of Maria Laguardia. Also discovered near the body was a collar with a silver pin attached. Family members produced photographs of Maria wearing the pin.

Police quickly zeroed in on the women who were last seen with Maria a full year earlier: Mrs. Concetta Forgione and her nineteen-year-old daughter, Stella. The third woman, now in Cañon City, was Angelina Garramone. Interestingly, the man who claimed to have seen the trio with Mrs. Laguardia was none other than Clemento Cellanto. He told police that he saw Angelina Garramone with the other women buying tram tickets to

Golden in August 1910. He stated that Angelina told him the next day that she had taken Maria to her husband.

Police brought the Forgione women into the station and interrogated them separately. Officers escorted them to South Table Mountain, bringing the ladies separately to the spot where Mrs. Laguardia's body was found. Upon arriving at the gulch, each woman blurted out a confession.

The stories they told were very much the same. Angelina had informed Maria Laguardia, who was illiterate, that she'd had a couple of letters from Mr. Laguardia, asking her to tell his wife to meet him up on South Table Mountain. At that time, South Table Mountain was a popular destination for hikers and picnickers from Denver, easily accessible on the tram.

On August 19, 1910, the four women took the Denver and Interurban tram to Golden. Along with the Forgione women, the party consisted of Maria Laguardia, Angelina Garramone and Angelina's baby. The Forgiones said that their job was to watch the baby. They arrived in Golden late in the evening—too late to climb up to the mesa. The entire party, including the baby, spent the night on benches at the depot.

Golden's landmark Castle Rock, located on top of South Table Mountain. *Photo by the author.*

At daybreak, they hiked up the trail to Castle Rock, a prominent butte on South Table Mountain. The party trudged around the mesa, searching for the elusive Mr. Laguardia.

At some point during what must have been an exhausting ordeal for Maria, she finally became suspicious. When they were near a place the newspapers called Long Gulch, she announced that she was going home and began scrambling down the gulch. Angelina scurried after the elder woman, pleading with her not to give up. When Maria ignored her, Angelina pulled out a butcher knife. She clutched Maria around the neck, exclaiming, "Oh, look at the big worm on your throat." Then she sliced Maria's gullet from ear to ear.[33]

After Maria died up on the mesa, the Forgione women watched while Angelina ripped open Maria's dress and found the money that Maria was known to carry. When she was done, Angelina shoved the body down the gulch and then kicked and scraped with the knife to send clumps of dirt down on top of the body.

While Concetta was still holding Angelina's baby, Angelina told her that she would kill her too if she ever said anything. She gave the Forgiones a portion of the loot from Maria's dress. Mrs. Forgione claimed that she returned it to Angelina the next day.

The three women plus the baby then trudged down the mountain and walked along the tracks to the Industrial School tram station. At some point, Angelina noticed that her long military cape was drenched in blood, so she prevailed upon young Stella Forgione to cram it under a cattle guard. They had also stolen some "holy cards" from among Maria's things. They found these smeared with blood as well. The trio disposed of them down a crack in the station platform.

They then caught the tram back to Denver, where Angelina was able to make it to a required 10:00 a.m. court appearance related to the forgery charges against her.

On November 6, 1911, Angelina was brought from Cañon City to Golden and arraigned on charges of murder. She pleaded not guilty, saying, "No, no. I could not be guilty of such a crime as that."[34] She said that Maria Laguardia was alive, had gone to California to join her husband and would surely show up to save her at any moment.

After two postponements, she went on trial on December 21, 1911. The prosecution's star witnesses were Concetta and Stella Forgione, both of whom had previously pleaded guilty to accessory after the fact with sentences of not more than two years. (No prison records exist for either woman.)

Angelina's attorney, Mr. Clover, created an uproar before the trial even got started when he tried to get the case dropped on the grounds that nobody

had actually proven that Maria Laguardia was, in fact, a human being. The paper quotes him as saying: "Why, how do we know…but what Maria Laguardia is a race horse or someone's cow or some thing. There is nothing in the information to show that she was a human being."[35]

The patient judge excused the jury and spent some time apparently researching the legal issues around human beingness, after which he overruled the motion and got on with the trial.

When opening his case, the district attorney explained to the jury that Angelina was considered a soothsayer and that the Forgione women had kept quiet for an entire year because they were terrorized by her and believed that she would cast a spell on them if they told about the murder.

The proceedings went slowly, as most of those involved spoke no English and the interpreter, Frank Potestio, struggled with the lengthy translations.

Maria's nephew, Dominick Tito, testified that on the day after Maria's disappearance, he asked Angelina where his aunt had gone. Angelina, apparently unconcerned about anyone actually checking on her story, told him that she had sent Maria to her husband at Eldorado Springs. As the days, weeks and months went by, Angelina continued to answer his queries with the promise that Maria was fine and that he would hear from her soon.

During the trial, Angelina's smiles and "flashes of wit" kept curious spectators entertained. When District Attorney Morgan asked her to remove her coat and gloves, she smiled at him and said, "I guess this is just a little garden party."[36] He complained about her "undue frivolity." Angelina pointedly asked if he had a rope ready for her. The *Rocky Mountain News* had nothing pleasant to say about her: "Mrs. Angelina Garramone, whose name has had somewhat the same effect upon the Italian colony of Denver for years past as the hiss of a snake upon a band of monkeys."[37]

Concetta and Stella Forgione both testified, relating nearly identical stories that deviated little from what they'd already told detectives. Although young Stella was described as pretty, the mother was described by the *Rocky Mountain News* reporter in colorfully unflattering terms:

> [H]*er shriveled, hard, cunning face, acrobatic with passionate Italian mobility, her beady, black eyes restless and peering like a monkey's and her brittle, falsetto voice, working in time to her emotions,* [she] *sat upon the witness stand in the district court at Golden yesterday and detailed the revolting murder of Mrs. Maria Laguardia on South Table mountain on the morning of August 20, 1910.*[38]

Angelina Garramone fixes her "hypnotic" stare upon the prison photographer. *Colorado State Archives.*

During her testimony, Concetta often glanced nervously in the direction of Angelina but "looked everywhere but into the dark eyes which the Italians believe have hypnotic power and can read their thoughts, their very souls."[39]

Mrs. Garramone leaned on her elbows and transfixed her accuser's back with a steady stare as Mrs. Forgione said, "She grabbed Mrs. Laguardia by the hair, pulled her head back and, as she said, 'Oh, godmother, you have a big worm on your throat,' she cut it with a butcher knife."[40]

At the end of the day of Concetta's testimony, Angelina spoke to reporters:

> *She lies. She lies. Just wait and you will see. She will be in hell before she gets through. She will think it over in Cañon City—there is lots of time to think in the penitentiary. She won't look me in the eye when she lies. She is afraid.*[41]

Prosecutors brought a box into the courtroom containing what was left of Maria and showed it to the jury, piece by piece. Angelina reportedly laughed during this process and remained unmoved until they brought out the skeletal foot, still wearing its shoe.

Mrs. Anne DeMotto, Maria's niece, identified the shoes as belonging to her aunt and fondly recalled tying the laces for the old woman when Maria wasn't feeling well. She testified that she recognized the blue calico because she herself had made the dress for her aunt.

Finobella Garramone, Angelina's son, testified against his mother. He and his father—Angelina's estranged husband, Luigo—had given police an earful about how Angelina had cheated her own husband out of a large amount of money.

The defense rested on an alibi that placed Angelina in Denver the day and night before the murder and the fact that she showed up for her 10:00 a.m. court appearance on the alleged day of the killing.

The prosecution disputed this alibi with testimony from an employee of the Industrial School in Golden, who said that he saw four Italian women at the Golden tram depot that night, corroborating the Forgione story. Clemento Cellanti also testified that he saw the four women get onto the tram to Golden. There was considerable speculation during the trial that Angelina had either killed Cellanti's wife, Mrs. Labata, perhaps because Mrs. Labata knew about the Laguardia murder, or that Angelina at least knew something about the killing. Mrs. Labata's murder was never solved.

At the end of a one-week trial, Angelina testified on Thursday night for two hours. She insisted that the Forgione women were lying. She said that Maria's missing husband had sent three letters, which Angelina read for Maria because Maria was illiterate. Mr. Laguardia, she said, was a fugitive from justice and ran off because the Italian community was going to hang him. She claimed that one of the letters said, "Dear Wife. I will come to Denver the Saturday before St. Rocco's day, Meet me at the loop at 15 minutes to 10, but for the love of God don't tell the family or let my nephew know. You know why."[42]

Angelina testified that the long-lost Mr. Laguardia showed up when the ladies were sitting on the bench at the depot. Mrs. Laguardia rushed into her husband's arms, the blissful couple boarded a tram for Eldorado Springs and that was the last anyone saw of them.

Golden police chief Armstrong later testified that Angelina at first told him she had put Maria on a Golden car but changed her story to Eldorado Springs.

Angelina also claimed that on the day before the murder she was in Denver. First she had gone to her attorney's office and then to the city park with the two Forgione women. They all spent the night in her room at a rooming house—not in the tramway depot as the Forgiones said.

During the examination by her attorney, Angelina protested that she was not capable of such a terrible crime:

Attorney Clover asked her if she had ever hurt anyone or whipped the children. "That's why I left home," she said, "because I would not whip the children. I never could stay around when a chicken or a duck was killed." [43]

She claimed that Mrs. Laguardia was alive and that the entire affair was an elaborate plot constructed against her by members of the Italian

community in revenge for losing their money in various real estate deals. She said that she had been in danger for many months from a diabolical figure named Clyde Cassidente.

Her attorney, Mr. Clover, spent two hours arguing on her behalf. He accused the district attorney's office, court employees and law enforcement of conspiring to bring about the death of Angelina Garramone. She was simply a victim of jealous persecution and revenge plots. During this speech, Angelina broke down and cried for the first time. Attorney Clover did not bother agreeing with Angelina's theory that Maria was actually still alive but rather proposed that the long-missing Michael Laguardia had killed his wife.

Clover's other tactic was to discredit Mrs. Forgione, which wasn't difficult. He brought up a horrific event from 1893, when Concetta Forgione and her ten-year-old son had been arrested for torturing her six-year-old daughter from a previous marriage. Concetta and the boy had burned the little girl's back, breast and private parts with hot flatirons and burning sticks and then hung her by the neck from a bedpost. Rescued by neighbors, the child was removed from the family. Although the boy said that his mother was the ringleader, he was sent to reform school for three years, and Concetta got only six months in the county jail as an accessory.

During their summation, the prosecution surprised everyone in the courtroom by demanding the death penalty for Angelina Garramone.

At 8:30 p.m. on Saturday, December 23, 1911, the jurors, described by a Denver reporter as "the stern farmer jury of Jefferson county,"[44] retired to deliberate the case. The following morning, they announced that they had reached a verdict, and Angelina was brought back in. She hid her face while the jury shuffled into the courtroom. The court clerk read the verdict: guilty of first-degree murder with a sentence of life imprisonment.

When asked if she had anything to say, this was Angelina's reaction:

> *Mrs. Garramone's wonderful smile again came into evidence and she tossed her head and said: "well, you can tell them this one thing. My conscience is clear and that will keep me from being unhappy. I know I didn't kill her, no matter what the jury thought. Mr. Clover has ask[ed] the judge for a new trial, and maybe I will have better luck the next time. Maybe Mrs. Laguardia will hear by that time and come and save me."* [45]

After the trial, Angelina came up with yet another explanation for the murder, this time laying the plot against her at the feet of Concetta Forgione's husband:

```
8304-GARRAMONE.
Recd.1-20-12.
County,Jefferson.
Crime,Murder.
Sentence,Life.
Occupation,Housewife.
Age,36.Weight 110.Height 5.0 1/2.Complexion ,Dark.
Hair Black,Eyes,Black.Short-Medium.Nationality,
Italian.
                    MARKS & SCARS.
3 marks below breast.
```

Angelina Garramone's Record of Convict. *Colorado State Archives.*

"What will they think when they learn that the body found had been thrown in the gulch by Nicola Forgione—Nicola Forgione," she repeated, "who works at the Coronado cemetery. He robbed a grave and put some of Mrs. Laguardia's clothes on the stolen bones that I might be accused and gotten rid of. O, they planned well to keep me forever away. I hope they have sweet dreams! God bless them!" [46]

Nicola Forgione was Concetta's second husband, who had survived a knife attack by her first husband back in the late 1880s.

Maria Laguardia's remains went to their final resting place in October 1911. The morticians reported that "it was a hard proposition to dress up just a few bones so they would look like a body."[47]

On May 24, 1922, after Angelina had served a little over ten years, Governor Oliver Shoup commuted her sentence and she was released on parole. Public records show glimpses of an Angelina Garramone in the Denver area during the 1930s and 1940s, but it is impossible to confirm her identity.

After the murder of Mrs. Laguardia, Stella Forgione changed her name to Ethyl Jones. When Angelina was released, Stella/Ethyl left Colorado and moved to Amarillo, Texas, where no one had ever heard of the Laguardia murder.

Mr. Bellew Runs Amuck (1912)

Southwest of Denver, along the eastern border of Jefferson County, lies the abandoned settlement of South Platte. Situated in a pretty valley at the confluence of the South Platte River and the North Fork of the South Platte (on Platte River Road), the remote spot was once a busy stage and train stop on the road to Leadville, Gunnison and other mountain communities. The Denver, South Park and Pacific Railroad left from Denver, chugged up the spectacular Platte Canyon to South Platte and then headed west through Pine Grove, up to Bailey and on to South Park. First constructed in the 1870s, the narrow-gauge line was shut down in 1937. During its heyday, the town of South Platte had a telegraph and post office and a hotel, but today it is a ghost town on the river, popular with fishermen, bicyclists, kayakers and hikers.

The South Platte Hotel, built about the turn of the century, was operated by Charles and Mata Walbrecht. On August 2, 1912, a local stagecoach driver named George Bellew suddenly decided that he'd had enough. He'd been hanging around the hotel for the past month, drinking and making threats to "clean out" the village. That Friday night, he arrived at the hotel demanding whiskey. Mr. Walbrecht was barely finished telling him to take a hike when Bellew pulled a gun and shot Walbrecht in the face.

Bellew then brought out a second gun and shot up the bar area. He rampaged into the hotel's kitchen, where he shot at and missed a young girl who worked there named Ethel Cathey. Next he tore into the dining area, where a number of people were eating supper. Mrs. Walbrecht was there, along with two California tourists, Mr. and Mrs. Harry Berman; the South Platte station agent and telegraph operator, J.A. Paine; and James McWhorter, a Kansas City pool hall proprietor.

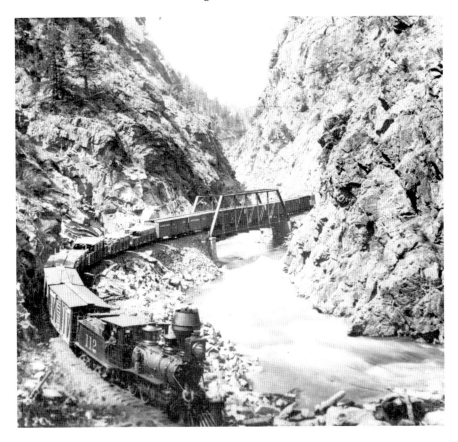

A narrow-gauge train chugs through the Platte Canyon between the village of South Platte and Denver. *Library of Congress, Prints & Photographs Division.*

Bellew shot Mrs. Walbrecht twice, both bullets hitting her arm as she raised it to shield her face. McWhorter tried to get up from the table and was shot in the left elbow. Bellew then fired off his remaining shots at the rest of the people at the table.

While Bellew was busy shooting at her customers, Mrs. Walbrecht managed to scurry out the door on her hands and knees and crawl off into a nearby field to hide. Bellew soon followed her. He spotted her among the weeds and shot her again, the bullet tearing into her left thigh. Without checking to see if she was dead or alive, he ran back to the front of the hotel, making a big ruckus and waving his guns around. He realized that Paine had just disappeared into the telegraph office and chased after him. Paine managed to connect with the telegraph office in Pine Grove, but before he

The South Platte River meanders through the quiet valley where the village once stood. *Photo by the author.*

could say anything, Bellew appeared at the window and aimed his gun at Paine's head, telling him he'd "blow h--- out of him if he called assistance or touched his keys."[48] Paine disconnected. Bellew told him he'd kill him if he tried contacting help again.

Not yet satisfied with his work, Bellew rummaged up a five-gallon can of kerosene, sloshed it on the hotel and started it ablaze. He then stood guard over the place with his guns and watched the hotel burn to the ground.

Meanwhile, the others were hiding in the fields. After a desultory attempt to find them, he gave up and ran back to his home about a quarter-mile away. He saddled up one of his stage horses and galloped off into the night, firing his pistols and shouting at the town that he'd be back to finish the job and that he'd never be taken alive.

When they were certain that the fellow was long gone, folks crept slowly out from their hiding places. They found Mr. McWhorter unconscious and followed the faint cries of Mrs. Walbrecht to find her lying in a pool of blood out among the weeds. Mr. Walbrecht had also lost a lot of blood.

Charles Walbrecht built this replacement South Platte Hotel after Bellew burned down the first. *Photo by the author.*

It was three full hours after Bellew's departure before the terrorized Mr. Paine finally summoned the nerve to call the Pine Grove telegraph office again.

Deputy Sheriff Ed Dennis (the son of Sheriff Joseph Dennis) left Golden early the next morning, but Bellew was long gone by then. Several posses formed, tracking Bellew's horse to Sedalia, where he had been seen boarding a Denver & Rio Grande train headed southeast toward Pueblo.

Despite Bellew's head start, within two days of the shootings, on Sunday, August 4, lawmen cornered him in La Junta. A fierce gun battle ensued that Bellew abruptly put to an end when he ran out into the middle of the road and shot himself in the head.

All of Bellew's victims recovered from their injuries. Later that same year, Charles Walbrecht rebuilt the South Platte Hotel. Today, it stands alone with its windows boarded up and the paint fading, the last remaining building of the village of South Platte.

A Most Tragic Corner
of the County (1866-1914)

In the 1850s, two ambitious Irishmen named Michael and Martin Lyden bought property and began raising livestock at the northern end of Jefferson County. They enjoyed great success and were soon reported to be quite wealthy. One of the brothers, forty-year-old Michael Lyden, built a home in the foothills near Ralston Creek.

About mid-June 1866, Michael Lyden was followed home to his ranch from Denver by four unidentified men. These men hid themselves in the bluffs overlooking his ranch. When the opportunity came, four shots rang out, and Michael Lyden fell with two bullet holes in his head and two more in his torso. Others nearby heard the shots and were at his side within a few minutes, but he was already dead. At least one of the witnesses had seen the men in the bluffs signaling to one another. Unfortunately, the shooters escaped before the sheriff arrived.

By February 1867, Michael's killers had still not been caught. Martin Lyden offered a $1,000 reward for information leading to the arrest of those who murdered his brother. A couple of weeks later, three prominent Denver men were arrested for his killing but were soon released on bail, and none was ever convicted of the crime. Unsubstantiated rumors circulated that the men had been acting as vigilantes and had assassinated Lyden for allegedly stealing stock.

Michael Lyden's murder was never solved.

In 1869, Martin Lyden discovered several rich coal seams on his property. In August of that year, he announced that he would be producing coal for sale by that fall.

In September 1870, only one year after Martin Lyden began his coal operation, a second tragedy struck. On a quiet Monday morning, a man

from a neighboring mine grew puzzled that there seemed to be no one about at the Lyden mine. Lyden's dog had been spotted on the property on Sunday, but Martin and two men who worked for him had not been seen since Saturday. The neighbor lit a candle and entered the mine tunnel. About sixty or seventy feet in, he stumbled over a prone body lying face down. Nearby lay the body of the dog. Realizing that he was probably in danger, the neighbor hurried out of the tunnel.

Rescuers arrived at the mine and removed the dead man, whose name was Patrick Stanton, along with the dog. They were unable to venture farther into the tunnel without first taking action to dissipate what is known as firedamp—a deadly and flammable gas that develops inside coal mines. Finally, they found two more bodies farther inside—that of Patrick Kelly, a miner, and Martin Lyden. The coroner determined that the men had been killed by firedamp probably on the previous Saturday.

The mine remained closed after Martin's death, and in February 1871, the coal bank caught fire due to "spontaneous combustion."[49] Later that year, the administrator of Martin's estate notified Lyden relatives that the estate would have to be sold in order to pay off what turned out to be a considerable amount of debt.

The mine eventually came under new ownership and operated until 1951 as the Leyden Coal Mine. It's not clear how the name "Lyden" morphed into "Leyden." In 1910, forty years after the death of Martin Lyden and

The Leyden Coal Mine. *Drawing by Richard Turner.*

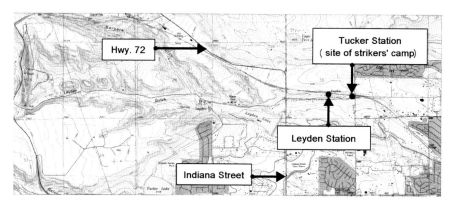

Location of the Leyden and Tucker tram stops. *U.S. Geological Survey.* Golden Quadrangle [topographic]. *1:24,000. USGS 1994. The USGS Store: Map Locator. http://store.usgs.gov.*

his men, a fire started in the engine room of the Leyden Coal Mine. That disaster claimed the lives of ten more coal miners.

Yet another tragedy occurred on the night of Thursday, February 26, 1914, during the statewide coal miners' strike. The strikers at Leyden had set up a tent colony near the Tucker Station of the Denver and Interurban tram (also referred to as the Denver Intermountain). They had been living in the camp since the previous fall, funded by the national coal miners' union. The population of the camp varied from fifty or sixty up to several hundred. Many of the miners were said to be "foreigners, many of them Russians," who a local newspaper reporter helpfully described as "of a quarrelsome disposition."[50]

According to eyewitness testimony, the trouble started the previous Sunday during a dance party. Walter Reynolds, the union finance officer, was ungracious in the manner in which he lorded his authority over others. Referred to by one reporter as Brazilian, Reynolds was also dubbed "the Mexican" because he had lived for many years in Mexico. He had particular trouble with a Russian miner named Pete Zbrenzi. During the dance, Reynolds and Zbrenzi got into a fight.

Later that week, Zbrenzi and several of his buddies—listed as "John Weinko, Victor Macharski, and two or three others with unspellable names"[51]—took the tram into Denver and got plastered. Returning to the camp, they decided that it was time to teach the pompous Reynolds a lesson.

They headed for Reynolds's tent, but he wasn't there. They staggered around the camp looking for him and finally were told that he was in the tent

of the Hoffmire family (also variously spelled Hoffameier, Haffemier and in numerous other ways). Inside the tent, the group was enjoying a pleasant evening, listening to music on the phonograph.

Thirty-one-year-old Benjamin Hoffmire was an electrician and strike organizer. He had just returned a couple of hours earlier from a three-month trip to Arizona. Mrs. Hoffmire was well beloved in the camp, taking charge of the women there and earning the nickname "Little Mother Jones" because of her work on behalf of the striking miners. The Hoffmire children were also present.

The tents were lighted inside so a viewer from outside could see the silhouettes of those within. The drunks stood outside the tent and called for Reynolds to come out. As Reynolds stepped into the night, Zbrenzi punched him and the brawl began. Someone had a gun and a shot went off, but no one was hit.

The peacemaking Hoffmires rushed out and stopped the fight. They invited Zbrenzi and his friends into the tent and tried to calm everyone down. They brought Reynolds back inside and tended to his injuries. When his wounds had been bound, he left. In his own tent, he armed himself with a rifle and strode back to the Hoffmires'. He stood outside the tent, cursing at Pete Zbrenzi and ordering him out. He began shooting.

Zbrenzi and his comrades hit the deck. Mrs. Hoffmire ran to the door flap of the tent, but her husband dragged her away. More shots rang out. Mr. Hoffmire let go of his wife, and she opened the flap of the tent, screaming at Reynolds. "Don't shoot! There are children in here!" She then turned back to her husband, who had sunk to the ground and was leaning against the stove without making a sound. Mrs. Hoffmire saw a splat of blood on his sleeve and assumed that he'd been shot in the arm.

She opened the tent flap and called out to Reynolds: "For God's sake, don't shoot any more…There are children in here. You surely don't want to shoot the children?"[52]

Meanwhile, John L. Britton, the president of the local union, emerged from his tent next door carrying a gun. He pointed it at Reynolds and ordered him to stop shooting. Reynolds obeyed but then backed up slowly into the darkness and fled.

Mrs. Hoffmire returned to her husband. This time, she realized that he had not been shot in the arm—the bullet had entered his head. An hour later, Benjamin Hoffmire died.

After the shooting, Reynolds ran to a small store about a mile away, where the proprietors knew nothing about what had happened. He told the

Tram no. 82, running between Denver and Leyden, was probably used by Reynolds to make his getaway. *Drawing by Richard Turner.*

storekeepers, P. Berchi and Frank Berchi, that a "scab" had shot a man and killed him and that he was on his way to Arvada to find the sheriff. The Berchis ran over to the strikers' camp to see what they could do, where they learned that Reynolds was the shooter. When they returned to their store, they discovered that Reynolds had helped himself to a hat and disappeared once again into the night.

A posse was quickly formed, including deputies from three counties, and the search for Reynolds began. The shooter had made good his escape, however. A week later, Sheriff Dennis received word that Reynolds had been spotted in Edgemont, South Dakota, reportedly headed for the coal camps of Wyoming. Sheriff Dennis offered a reward of $100 for information leading to the arrest of the killer.

Five months later, word appeared in the *Transcript* that the sheriff believed that Reynolds had been located and that he would soon bring him back to face trial. However, no further word about Reynolds showed up in the papers. There were no reports of Reynolds being brought in, no notice of a trial and no corrections records exist for him.

A Muddled Case of
Frontier Justice (1868)

Frontier Colorado endured its share of two-legged marauding pests, and one of the baddest outfits of outlaws was the Musgrove gang. In the late 1860s, L.H. Musgrove ran a loyal band of stock thieves, robbers and murderers, mostly in the Kansas, Colorado and Wyoming Territories. The undisputed boss of these fine citizens, Musgrove was described as "large [in] stature, of shapely physique, piercing eye, and steady nerve…a commander who must be obeyed."[53] This "shapely" fellow had killed at least four men.

After he and his gang rampaged through the territories for several years, lawmen in Wyoming finally snagged Musgrove in 1868. They handed him over to Colorado officials, who hauled him to Denver on a stagecoach and stuck him in the Arapahoe County Jail. Shortly thereafter, rumors began to circulate in Denver that as many as twenty members of Musgrove's gang were migrating to the city intending to break him out.

One of Musgrove's faithful comrades was Ed Franklin. He had recently achieved glory as a desperado after stealing nineteen mules from Fort Saunders in Kansas. Tracked and cornered by seventeen soldiers from the fort, he fought them off for an hour before he was shot in the breast and captured. Nobody expected him to live. However, he not only recovered in the fort's infirmary, he also escaped. He soon heard of Musgrove's situation and headed for Colorado, arriving in Denver with another fellow of infamous reputation, Sanford Duggan.

Duggan was not part of the Musgrove gang but was well known for having murdered a man in Black Hawk and nearly killing a woman he lived with in Denver, a prostitute named Kittie Wells. Like Franklin, he had escaped from jail some time before, after which he somehow convinced the people of

Laramie City, Wyoming, to make him marshal. Those good folks soon got wise to his true character, however, and chased him out of town. On his way back to Denver, he hooked up with Franklin.

Upon arriving in town, Franklin and Duggan quickly got to work—robbing two men in the streets. Franklin took time out from his "chores" to visit Musgrove in jail, during which visit they presumably discussed plans for the latter's escape. As it turned out, however, their second robbery victim was a justice of the peace named Orson Brooks. While they relieved him of the $135 he had in his pocket, Brooks was busy hiding the fact that he recognized Sanford Duggan. It just so happened that Brooks had presided over Duggan's trial for assaulting Kittie Wells.

In no time at all, the word went out and local law enforcement mobilized to recapture the outlaws.

Franklin and Duggan took their hard-earned dollars to Golden City, where they checked into the Overland Hotel and embarked on a drinking binge. There, Duggan made the mistake of using a twenty-dollar bill that he had stolen from Brooks. Brooks had reported this particular bill as being marked by a noticeable tear, and folks in Golden City and elsewhere had been alerted to be on the lookout for it. Jefferson County sheriff John Keith soon notified Denver City marshal and owner of the Rocky Mountain Detection Association, "General" Dave Cook, that the desperados were hooting it up in Golden City.

Cook, who had bestowed on himself the dubious title of "General," rounded up five men and headed for Golden City. On Sunday, November

Golden City as it looked in the 1870s. *Library of Congress, Prints & Photographs Division.*

23, 1868, at about nine o'clock in the evening, they reached the outskirts of town. They met up with Sheriff Keith, who said that Franklin had staggered back to his room at the Overland and Duggan was still drinking at a popular place run by Jack Hill. Hill's saloon was located right next door to the Overland.

Jack Hill was a man of good reputation, famous in Golden City for his "three minute free drinks." When business was slow, Hill would go to the door of his saloon and blast his trumpet. The trumpet meant one free drink for each man for the next three minutes. The sound of the trumpet blaring across the streets of Golden City always led to the mass abandonment of projects by the town's male citizens and a mad dash to Hill's saloon.[54]

The lawmen decided to take Duggan first and headed for Jack Hill's saloon. The posse passed two men walking along the main street, one of whom they recognized as Duggan. The second man was Miles Hill, brother of the saloon's proprietor. Miles Hill was also a popular local man of good reputation, whom Duggan had somehow befriended.

The posse took no action but rather watched as Hill and Duggan went back into the saloon. They surrounded the place. Duggan had realized something was up, and the lights inside the saloon suddenly went dark. As the lawmen crept closer, someone appeared in the doorway brandishing a gun, and the shooting started.

After a brief gun battle, the lawmen made their way into the saloon. Inside, they found Miles Hill lying on the floor, mortally wounded. The slippery Duggan was nowhere to be found, having somehow escaped once again. Miles Hill lingered in agony for some hours before dying early the next morning.

Another version of this story appeared in the Central City paper, noting that Miles Hill and Duggan had been playing billiards when the gun battle began and that Hill accidentally shot himself when he handed Duggan his pistol as the lawmen approached. Whichever version is closer to the truth, the end result was the same: Miles Hill lost his life and Duggan got away.

Despite what could easily be considered a significant screw-up, the night was still young, and the second desperado was hopefully still in his room at the Overland Hotel.

Cook and the posse crept up the creaking stairs of the Overland. They tried the door to his room and found it unlocked. Quietly, they pushed it open.

Inside, Franklin snored contentedly. His empty gunbelt hung from the bedpost, which meant that he probably had the weapon under his pillow. His

The Overland Hotel (left) and Jack Hill's saloon (right), where Ed Franklin and Miles Hill were killed. *Drawing by Richard Turner.*

bare chest revealed the still-unhealed gunshot wound that he had received during the fight with the soldiers from Fort Saunders.

The lawmen snuck forward, shining a candle in his face to make sure they had the right fellow. His eyes opened.

Cook produced a pair of handcuffs, saying, "Franklin, we want you."[55]

Franklin reached under his pillow, and one of Cook's men bashed him on the head, knocking him out of bed. A struggle ensued as the lawmen tried to get Franklin handcuffed, during which there was a lot of cursing and two gunshots, both of which hit Franklin in the chest. He died on the spot.

Cook and his men took a lot of heat for their actions during this noisy and bloody night in the usually quiet village of Golden City. Miles Hill was a popular man, and many in town were angry at his death—not to mention Duggan's escape.

Cook's autobiography declared that "local prejudice was allowed to control the deliberations of the Coroner's jury, the members of which were not in possession of all the facts in the case."[56]

The "prejudiced" part of the coroner's report noted "that the said Miles Hill came to his death by a pistol shot fired by one of the officers sent from Denver to arrest Sam. Dugan [*sic*] and Ed. Franklin; and we consider that said officers acted in a very careless and reprehensible manner in the performance of their duty."[57]

As for Franklin, the *Colorado Transcript* offered this opinion:

> *As Franklin was known to be a desperado of the worst stamp, and was doubtless guilty of the crimes charged upon him, no one here regrets his death, but many think that three armed officers should have been able to hand-cuff one unarmed, naked man, and given the law a chance at him. As the coroner's jury have exonerated the officers from blame, however, we are not inclined to censure them. He doubtless got what he deserved.*[58]

After Cook paid the Overland fifty dollars for the bloody mess they left in the hotel room, they carried Franklin's body back to Denver. There they laid it out in a "rough box" and put it on display in front of the jailhouse so that the townsfolk could stroll by for a free peek. Justice Brooks came along and identified him as one of the men who robbed him.

The morning after the shootout in Golden City, a Monday, the streets and saloons of Denver buzzed with excitement over the news. Rumors about the gun battle flew far and wide, and the attention of Denver's citizenry inevitably began to focus on the rapscallion they had in their own jail—L.H. Musgrove. Stories circulated about the desperados from Musgrove's gang possibly still lurking around Denver, busy with plots to spring him loose. One story getting folks riled up was that Ed Franklin had visited Musgrove in jail.

By noon that day, as Cook and his men recovered from the long, disagreeable night's work, the notion gathered steam in the streets that Musgrove ought to be lynched. By three o'clock that afternoon, men were gathering on Larimer Street. Within a short time, a mob—described by some as several hundred and others as fifty of the "best" citizens—was on its way to the Arapahoe County Jail, where Musgrove sat in a cell. Once the group arrived, the members took a hasty vote about whether Musgrove ought to be hanged or not. The almost unanimous decision was "Aye."

The jailers put up no resistance as the group entered the cell and grabbed hold of their quarry. They hauled Musgrove out to a bridge over Cherry Creek, where they stood him up on a wagon. There, he requested a moment to write letters to his brother and his wife, all the while having cords tied around his ankles and neck. In his letters, he asked his brother in Mississippi

to take care of his children, who lived in Napa Valley, California, and assured him that he was innocent. To his wife Mary in Cheyenne, he wrote that he was being hanged "because I am acquainted with Ed. Franklin" and told her to "sell what I have and keep it."[59]

While a solitary citizen, Captain Scudder, tried to dissuade the mob from its work, Musgrove rolled himself a final cigarette. Once that was finished, someone pulled his hat down over his eyes, and the wagon began to move. Sensing the movement, Musgrove took a leap but unfortunately landed still in the wagon. He tried it once more, and this time the wagon moved away quickly enough and Musgrove hit air, his neck broken.

The *Rocky Mountain News* reported: "His hat had all the time been pulled down over his face, but after he had hung perhaps five minutes, it was taken off, and his countenance shown. It was villainous enough."[60]

It wasn't long before Duggan was captured again near Cheyenne. "General" Dave Cook traveled there himself to bring back the prisoner, paying the stagecoach driver to double his speed so that they would arrive in Denver at an odd hour, hopefully avoiding any additional mob action. Nevertheless, they were quickly spotted as they entered Denver, and the coach made a mad dash to the Larimer Street jail. Cook, who often boasted that he never gave up a prisoner to a mob, hastily handed Duggan over to county authorities and beat it out of there. By 4:00 p.m. that afternoon, the streets were lined with eager onlookers, including children, waiting for another necktie party.

Later that evening, when many had given up and gone home for supper, officers moved Duggan from Larimer Street to the city jail on Front Street. As the wagon crossed a bridge, it was suddenly surrounded by men demanding that the deputies surrender their prisoner. With little ado, Duggan was handed over. This time, the vigilantes drove their man to a street called Cherry Street and positioned him in the wagon under a large tree. Duggan denied doing much wrong except for robbing Brooks, and he assured them that he only did it out of desperation. He asked for a Catholic priest. He said that his death would kill his mother. Witnesses reported him sobbing like a baby. Finally, someone sent the wagon moving, and Sanford Duggan fell eighteen inches to his death.

The McQueary-Shaffer
Feud (1907)

People said it all started a few years earlier with a dispute over a horse race. Still, the details of the McQueary-Shaffer feud had become foggy in the minds of citizens living in the Upper Platte region around Shaffer's Crossing and Pine Grove. That the feud was still going on became sharply apparent in August 1907 at Pine Grove—this time someone got killed. The reason for the fight was a pile of railroad ties.

Thirty-five-year-old Grant McQueary operated a sawmill and lived on his property located about a mile south of Shaffer's Crossing. He had a wife, Helen (called Nellie), and two children, Earl and Gladys. The extensive McQueary clan was well known throughout the region. Grant's cousin, Fount McQueary, lived at Hot Sulphur Springs and ran a popular drinking house and hotel there, along with a stage line between Hot Sulphur Springs and Georgetown over Berthoud Pass. Grant's brother, Stillwell McQueary, was marshal of Hot Sulphur Springs. Grant's uncle, H.M. McQueary, was famous for his big gold strike at the Mecca mine near Breckenridge.

Albert Shaffer was just a lad, seventeen years old, at the time of the railroad tie affair. He and his brother Charles were leasing the Bell ranch, which adjoined Grant McQueary's property. Their father, Samuel A. Shaffer, founded Shaffer's Crossing in the late 1870s and ran a roadhouse there. Located on today's Highway 285 at Elk Creek Road, Shaffer's Crossing was a stage stop on the road from Denver to South Park and Leadville.

One of the products of McQueary's mill was railroad ties, which he'd been piling up on some government land nearby. Someone had been stealing them, and he suspected the Shaffers. On this particular day, finding more ties missing, McQueary headed over to the Shaffer place, where he

accosted Charlie Shaffer. Charlie admitted that his brother Albert, called Bert, had brought some ties in. Bert was summoned out of the ranch house, whereupon McQueary called him some foul names and accused him of being a thief. Shaffer said that he only took the ties because they were on government property and that if McQueary wanted them back he could have them.

The shouting match escalated into a physical brawl, which Shaffer ended by shooting McQueary dead. Shaffer fled into the hills but was quickly captured by Jefferson County law enforcement. Neighbors soon took sides. Friends of McQueary demanded justice, saying that he had been unarmed and was murdered in cold blood. They vowed revenge against the Shaffer family.

Others sided with the Shaffers, saying that both brothers had excellent reputations and that Grant McQueary was known for his quarrelsome nature.

To remove Shaffer from the threat of lynching, Sheriff Whipple and Coroner Davidson took the prisoner down to Golden for the inquest.

Three eyewitnesses testified at the hearing: Charles Shaffer; his wife, Pearl; and Wilbert Matthews, a thirteen-year-old boy who worked for the Shaffers.

All three told the same story: McQueary arrived at the ranch early Friday morning and accused them of stealing the railroad ties. McQueary attacked Bert with a rock and a gas pipe five feet long.

Bert Shaffer also testified. He said that he knew about McQueary's terrible temper and that McQueary attacked him with whatever weapon he could find. He said he tried to get away from the man but that he was finally cornered and managed to grab his rifle and fire off a wild shot. The bullet went into McQueary's heart and killed him.

Dr. D.E. Garvin of Golden testified about bruises he'd found on Bert Shaffer's body caused by the beating from McQueary.

No witnesses appeared at the inquest on behalf of the victim, as it was apparently too far for them to travel. In its conclusion, the coroner's jury found that Bert Shaffer had shot Grant McQueary in self-defense.

After Shaffer was released, rumors circulated about the hostile feelings against the entire Shaffer family in the area. The McQueary family and their supporters complained bitterly that the hearing had been held so far away in Golden, and they swore that they would drive the Shaffers from the region. Folks declared that only the "lack of organization" had prevented a delegation from visiting the Shaffers and running them off. Bert Shaffer, along with Charles and Pearl, soon moved away. Bert relocated to

Today's Shaffer's Crossing is a bucolic setting on Highway 285 at South Elk Creek Road. *Photo by the author.*

Washington State, where he became a teacher and died in 1942. Charles and Pearl settled in Wyoming, where they had over half a dozen children.

Grant McQueary was buried in the Conifer Cemetery. Tragically, Nellie and Grant McQueary's son, Earl, died on June 8, 1911, from an abscess on his head. He was thirteen.

Murder of the Judge's Son (1916)

It was a regular vacation party at Gill's Resort, a remote fishing and recreation spot located near the southern tip of Jefferson County. Established on Wigwam Creek a few miles downstream from Cheesman Reservoir, in 1916 Gill's Resort was owned and operated by Henry C. Gill, who also ran a sawmill nearby. Five years later, on February 28, 1921, a group of prominent Coloradans, including Frederick Bonfils, purchased the resort and transformed it into the exclusive Wigwam Club. The oldest fishing club in Colorado, the Wigwam Club still operates today as a private institution sometimes dubbed the "Millionaires Club."

Several couples had arrived together and rented Gill's Resort cottages that June of 1916: Mr. and Mrs. C.W. Nelson of Kansas City, Mr. and Mrs. James R. Graves of St. Paul, Mr. and Mrs. R. Hooper of California. Also with the group was thirty-two-year-old Frank Hughes Turner—the son of a former appellate court judge of the Sixth Judicial District in Texas, recently removed to Arkansas, where he was a prominent politician. Another well-known member of the Turner family was Frank's sister, the famous silent film star and stage actress Maidel Turner.

One more mysterious guest at the resort was a twenty-five-year-old woman, sometimes called Mrs. Brown and other times called Mrs. C.E. Wilson. She and her husband, as it turned out, had need of more than one name.

It wasn't clear whether anyone questioned Mrs. Brown's sudden departure from the resort. One day she abruptly sent her trunks to the train station at South Platte, and she quickly followed, boarding the earliest train for Denver. The fun vacation getaway turned sour for the group the next day.

The victim's famous sister, the actress Maidel Turner (right), appeared in more than sixty films. *Library of Congress, Prints & Photographs Division.*

Late on that Friday night, most of the vacationers were clustered in the bedroom of the cottage rented by the Nelsons. While the women lounged on the bed, the men were on the floor shooting craps at fifty dollars per throw. Mrs. Hooper was puttering about in the kitchen when the departed Mrs. Brown's husband, James Brown, suddenly burst in through the kitchen door brandishing a revolver. Ignoring her cries, he shoved her aside and strode into the bedroom. Frank Turner grabbed one of his craps partners and tried to hide behind the fellow's body, wailing at Brown, "My God, Don't shoot! I'll pay you all that I owe you!"[61] The two craps partners wriggled away and crawled under the bed.

Brown did not speak. He steadied the revolver on his left forearm, aimed straight at Turner's head and squeezed the trigger. Turner went down with a hole in his forehead. Brown left the room and walked silently out of the house.

The terrified gamblers spent the next fifteen minutes sorting out their stories before raising the alarm with the resort folks.

As soon as they were notified, Sheriff Joseph Dennis and Coroner William Woods took the train from Denver up to South Platte and rode an "auto stage" the rest of the way to the resort. When they arrived the next

morning, the stories they got from the witnesses were sketchy. One thing was clear—everyone present was well acquainted with both Frank Turner and his assassin, and they all seemed to be hiding plenty from the officers.

Sheriff Dennis quickly formed a posse to search the surrounding mountains. Brown had obviously planned the whole thing in advance and had his escape route well organized. On the afternoon of the shooting, Brown had rented a horse from Maurice Weinberger, proprietor at Decker Springs Resort. Brown told Weinberger that he was on a fishing expedition and wanted a horse that was fast and sure-footed. Weinberger noticed that Brown did not follow the stream—odd for someone going fishing—but instead rode up the trail leading to Gill's.

The sheriff's posse tracked Brown's escape route down the canyon. Brown rode his horse only a short way and then turned it loose. He headed on foot up a steep gulch that led back to the road, where he had either stashed a vehicle or was picked up by someone. Investigators surmised that he then made his way to Sedalia or other nearby town, where he could escape by train.

Investigators also agreed that Mrs. Brown knew what was coming and that her departure was part of the plan. The witnesses told the sheriff that Turner and the Browns had formerly been close friends, the group all having vacationed together at Gill's the previous summer. However, something had gone amiss and the relationship cooled. They said that Mr. Brown did not talk about himself much when they met him in the past. Some said that the couple were from Chicago; others claimed that they were southerners.

When officers examined Turner's body, they were intrigued by the presence of three $50 bills clutched in his fist. They also found $500 in his pockets. By Monday morning, the sheriff had arrested Turner's craps partners for illegal gambling. They each paid a $100 fine and were released.

Early in the investigation, Sheriff Dennis theorized that the whole group was part of an organization of illegal gamblers who were using the resort as their summer headquarters. He hadn't yet decided whether Turner was also a member of this gang or whether he was a dupe.

Within a week of the killing, investigators had uncovered evidence that pointed to much more than gambling. The vacationers were suspected of being part of an international gang of swindlers and blackmailers who moved from country to country, engaged in con games targeted at rich folks with something to hide.

Following the trail of Mrs. Brown, police discovered that she had failed to call for her trunk at the train station in Denver. Going through the trunk, they found

paraphernalia usually carried by confidence men—a telegraph code sheet,
Mexican money, bogus drafts, charts and other articles. Wilson, or Brown,
is known to be wanted for swindling several persons out of large sums. He is
a character, according to Leonard DeLue of the DeLue Detective agency, who
is known to the police of every large city, but has always evaded arrest.[62]

Jefferson County district attorney Sam W. Johnson uncovered more intriguing evidence. He learned that two weeks before the murder of Turner, Brown and his wife had arrived in Colorado after fleecing a wealthy New Yorker in Havana, Cuba. The con game involved wiretapping and blackmailing the New Yorker out of a considerable sum of money.

Once in Denver, they stayed at 2216 Welton Street with a friend of Mrs. Brown's. They soon felt the heat of law enforcement on their trail, however, and Mrs. Brown relocated to the remote Gill's Resort to wait for things to cool off. The whereabouts of Mr. Brown during that period was unknown.

Investigators also found a few clues about Mrs. Brown's movements after the shooting. She had rented a room at the Keiserhof Hotel in Denver but did not actually stay there. They traced her to Eldorado Springs, but she was gone before they could catch her.

Undoubtedly to the consternation of Frank Turner's well-known and highly respected family, investigators also discovered that Turner himself was involved in the Havana confidence game. In fact, he was said to be Brown's former partner, and the two had a falling out, apparently over money.

By September, authorities still had not apprehended the Browns, but stories were all over the press about a blackmail syndicate operating out of Denver and Chicago. Word spread that while at Gill's Resort the entire gang was cooling its heels after successfully staging a "badger game" on a prominent Denver man. The badger game involved one of the women of the group luring the Denver man, who was married, into a compromising position and blackmailing him. Agents who uncovered this scheme very kindly kept the married man's name out of the papers.

At the end of September, 1916, the case suddenly heated up as a "Mr. Evers," also referred to as "J.C. Davis," was arrested in Chicago. Authorities there, comparing pictures and a description of Mr. Brown, aka Mr. Wilson, said that they were certain that their Mr. Evers, aka Davis, was indeed the same man who had shot and killed Frank Turner. District Attorney Johnson promised that the fellow would soon be brought to Golden and put on trial for murder. He authorized Detective Leonard DeLue to travel to Chicago to fetch the prisoner.

Unfortunately, this turned out to be a false lead. Even as DeLue departed for Chicago, another clue came into the office that pointed in an entirely different direction. Jefferson County special investigator Harry Mullenbrock and District Attorney Johnson announced that the Chicago man was not the right fellow and that they had reason to believe that the elusive Mr. Brown never even left Colorado. This new story said that, immediately after shooting Turner, Brown had hurried in an automobile over the Nighthawk Hill Road and then up north to Brighton, where he caught a train to a sanitarium. There, ever since the shooting, he had been receiving treatment for a serious stage of cancer.

Like the Chicago story, this trail led nowhere.

Authorities also had their eyes on a man believed to be J.R. Farrell, one of the craps shooters. They were also shadowing a couple of "attractive" Denver women associated with the killer.[63]

Despite all these leads, the elusive Mr. and Mrs. Brown vanished for the next four years.

Then, in January 1920, after being trailed all over the United States, Cuba and Mexico, Mr. Brown abruptly appeared in Golden and gave himself up. He told authorities that he was tired of being on the run, but the more cynical observers guessed that he had organized some sort of defense that he thought would get him off.

Although Mrs. Brown was not with him, authorities prevailed on him to convince her to come in as well, as she was part of the charge sheet. She was living in Juarez, Mexico, and after being contacted by her husband, she soon arrived to face charges with her husband. Mr. and Mrs. Brown posted $5,000 each for bail and awaited trial.

The cynics were proven correct. As authorities tried to build a case against the Browns, they were unable to locate a single witness to testify against Brown or make any sort of statement whatsoever. (Apparently, if there were any written statements from these witnesses, they were insufficient.) Officials suspected that the witnesses had arranged with Brown to stay undercover. This left Brown's version of events as the only story, and he claimed that he had shot Turner in self-defense.

In the end, Brown pleaded guilty to involuntary manslaughter, and Judge Morley handed down what must be one of the lightest sentences in Colorado history: twenty-four hours in jail.

The Headless Skeleton (1924)

O n a Friday in late spring 1924, a group of young folks was hiking up a small ravine in Golden Gate Canyon northwest of Golden. There, one of the hikers stumbled over a headless skeleton.

They quickly contacted authorities, who searched the area and found a weather-beaten hatband with two holes in it. Sheriff Kerr and the coroner concluded that the holes were caused by bullets. The clothing on the skeleton was tattered but of high quality, with light undergarments, leading investigators to surmise that the man had been killed in warm weather. They believed that the body had been lying in the ravine exposed to the elements for at least two years. Based on the position and condition of the skeleton, they also guessed that he'd been standing on a rocky outcrop overlooking the ravine, was shot and fell. Beneath his body, they discovered a pocketbook containing $235 in silver, along with four unidentified keys.

The following Sunday, searchers found a portion of jawbone along with a tuft of brown hair. Despite searching extensively, investigators never found the rest of the head.

Based on the style of the clothing and the color of the hair, they surmised that the victim was probably a young man.

Authorities sent out notifications to other agencies with a description of the body, clothing and keys. Within two weeks, they received a request from a sheriff at York, Nebraska, saying he'd like to have a look at the material. Several years back, a Nebraska police officer named John Afferbach had disappeared while traveling with a prisoner from Lewiston, Montana, to York, Nebraska.

The prisoner, Harry Randolph, had stolen a car in York and was later arrested by Montana authorities. Officer Afferbach had driven to Montana to fetch Randolph. He picked up the prisoner and headed back toward Nebraska. During this trip, he and Randolph disappeared, and Afferbach was never heard from again.

A year after the disappearance, Randolph was arrested by police for stealing another car. When officers questioned him about Afferbach, he claimed to have no knowledge of what happened to the policeman. Randolph was sentenced to a year in Nebraska State Penitentiary for auto theft. Soon after his release, during yet another attempt to steal a car, he fought a gun battle with police and was shot and killed.

The mystery of Afferbach's disappearance had never been solved. Authorities guessed that Randolph had somehow overpowered the officer and done away with him, but they were never able to prove anything and the case went cold.

After seeing the notice about the skeleton, the sheriff of York County traveled to Golden, where Sheriff Kerr showed him everything they'd found. The Nebraska sheriff confirmed that this was the body of Officer John Afferbach. The skeleton was sent back to Afferbach's family for burial.

It wasn't clear how the officer and his prisoner ended up in Golden Gate Canyon, which was a considerable distance from their route. It's likely that Randolph got hold of Afferbach's weapon and forced him at gunpoint to drive south into Colorado and the foothills of the Rockies.

John Afferbach was the first lawman to die in the line of duty in Jefferson County.

A Divorce Most Foul
(1883)

M armaduke P. Switzer's version of his divorce was so different from that of his wife, Ella, it's hard to believe that the two were talking about the same marriage. Just about the only fact they agreed on was that they had two children—a seven-year-old boy and a three-year-old girl.

THE WIFE'S STORY

Mrs. Ella Switzer, a pretty woman in her mid- to late twenties, claimed that she had suffered from extreme cruelty and outrageous abuse at the hands of her husband. She said that they'd been married for about ten years and had moved from Atlantic, Iowa, to Denver in 1879. She endured this terrible abuse for as long as she could for the children's sake. In the autumn of 1881, she stopped living with her husband as a wife (sharing his bed). Six months later, still living with Switzer, she developed an innocent "correspondence" with a childhood friend from back in Iowa, a man in his early thirties named Theodore Jones.

A few months after that, Switzer took out a loan on his Denver property for $800, gave Ella $80 and took off for Gunnison. In the fall of 1882, while Switzer was still in Gunnison, she divorced him. She insisted that she did not divorce him because of Jones but rather because Switzer abused her. She changed her name back to Ella Storer and moved to Golden so she could put her seven-year-old boy, Montie, into the reform school there. This drastic step was necessary, she said, because she could not support both of her children and received no help from her ex-husband. She had tried to

get Switzer to take Montie, but he refused to take his son. The difficulty of her situation deepened when young Montie protested against going to the reformatory because his father had told him that it was a prison (it was).

In Golden, she started a quiet new life, but Switzer would not leave her alone. He came to her home twice a week and badgered her with his old abusive complaints.

Her companion and helper during this troubled period was Theodore Jones. Jones worked for the Colorado Central Railroad as a bridge carpenter. Mrs. Switzer claimed that Marmaduke had been jealous of Jones for years but that he had no reason to be concerned about their relationship.

The Husband's Story

An entirely different account of the situation came from Marmaduke Switzer's Denver business partner, Mr. Chris Le Bert. Le Bert described a "sober, reliable, and industrial" Marmaduke Switzer. Born in Pennsylvania about 1850, Switzer had come to Colorado from Iowa two years earlier and had been married eleven years. Switzer enjoyed a happy marriage until things went sour eight or ten months earlier, when Theodore Jones entered the picture. Theodore Jones was already known to the Switzers, as he came from the town of Wyota, which was near Atlantic out on the Iowa prairie.

Once Theodore Jones arrived, he and Ella began spending a great deal of time together. They were not terribly discreet about their friendship, and friends of Switzer took notice and warned him not to put up with it. However, the long-suffering Switzer trusted his beloved wife and did not take his friends' advice to forbid Ella from seeing Theodore. He even stayed home with the kids while Ella and Theodore went out riding together.

Switzer's ambition was to move out of Denver and buy a ranch somewhere in Colorado. With this in mind, he borrowed $800 by mortgaging his Denver property. Leaving the money in Ella's care, he took off for the Gunnison area, where he was scouting for ranching properties. Unfortunately, he fell ill during this trip and was laid up for several months. Finally, he was strong enough to make the trip back to Denver, where an ugly surprise awaited him.

During his absence, Ella had divorced him without his knowledge. She moved to Crested Butte and opened a restaurant, presumably with the $800. This venture failed, and Ella soon moved to Golden, where her new paramour, Theodore Jones, lived.

THE CRIME

On Sunday, February 13, Switzer told Le Bert that he wanted to take the tram out to Golden to see the children, but he was broke and decided not to go. On Monday morning, February 14, 1881, Switzer failed to show up for work at Le Bert & Switzer, the sign painting business they operated on Larimer Street in Denver.

On this Valentine's Day, according to Ella Storer, her ex-husband showed up at her door at 9:30 a.m. She later described for a reporter his behavior that morning:

> [He walked] *in without ceremony, and rushed frantically through every room in the house and even into the back yard before addressing her. He then sat down and commenced abusing her in his usual shameful manner. Shortly she saw him glance out of the window and reach for his revolver. At that moment she saw Jones approaching…and she warned him to look out for himself as Switzer had a revolver.*[64]

At the preliminary hearing, she described the scene that morning a bit differently, saying that he

> *went all through the house and looked out at the back door as if looking for some one, but did not say anything. He sat down to breakfast with me; we conversed, but Jones' name was not mentioned. He remained at my house until 12 o'clock and then left for the depot. I told him the train to Denver left before noon. He returned about 12:30; did not say what he came for. We were in the room until about 1 o'clock, when suddenly Switzer jumped up, turned very pale, and put his hand back to his hip pocket, looking out of the window at the same time. I then heard footsteps outside, and believing it was Jones, I opened the door when Jones knocked, and said be careful, this man has a revolver.*[65]

The two men had a heated exchange, each making threats against the other. Ella asked them to remove their argument from the house and away from the children, and Jones suggested they walk over to the Burgess House hotel, where he was staying.

The two men left Ella's place on Arapahoe Street and walked to the corner of Garrison (today's Ninth Street). Ella watched anxiously from her porch until they turned the corner, where they headed up Garrison toward Jackson

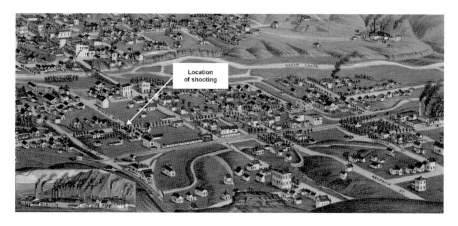

Detail from *Bird's Eye View of Golden, Colo.* (1882), showing where the action took place between Switzer and Jones. *Library of Congress, Geography and Map Division.*

(once called Miner) Street. When they reached the intersection of Garrison and Jackson, Switzer suddenly pulled out his Smith & Wesson revolver and began shooting. Jones tried to run, but after several shots he seemed to give up, turning to face his killer and lifting his arms to the sky. Switzer shot him again in the chest. Switzer shot Jones five times.

Ella Storer heard the shots and ran down the street to Jones, knelt over his body and caressed his face. Switzer was already jogging back up the street the way they had come. Nearly half a dozen citizens witnessed the shooting, and two young Golden men, Edward H. Howins and George Vogle, chased after Switzer. At the corner of Washington and Garrison, only a block away, they tackled him, taking his revolver and holding him in citizen's custody until Deputy Sheriff Todd arrived.

Meanwhile, Jones lay in the street and died a few minutes later. Several witnesses picked up his body and carried it back to Ella Storer's home, where the coroner came and made his examination. Jones had been shot near the heart, in the abdomen, in the sternum, in the shoulder and in the hip. From Jones's pocket, the coroner removed a bundle of letters, which were later reported to be love letters written to Jones by Ella Storer.

As was the usual procedure in those days, a lynch mob quickly formed, but for once they were dissuaded and Switzer survived to live another day. At 2:30 p.m. that same afternoon, Switzer stood before Justice Boyd and asked for a delay until the following day so he could get hold of a lawyer from Denver.

THE PRELIMINARY HEARING AND PUBLIC OPINION

The murder was the talk of the town, and absent the customary lynching, most of the speculation centered on whether Switzer would hang.

The preliminary hearing, held a few days after the shooting, was packed with curious spectators. Though the *Colorado Transcript* described Switzer as "tall and good looking," the *Golden Globe* reporter offered this opinion of the prisoner: "His countenance was not very pleasant, and his face showed signs of much trouble and his eyes had a vacant stare, though he kept them turned to the floor most of the time. In his hands was his fur hat which in his nervousness received a good deal of brushing and turning over."[66]

Ella Storer received a more generous description from the *Globe*: "She is a little lady of quite good form and young looking. She has [a] round, full face, light complexion, blue eyes, dark auburn hair, and a pleasing countenance…The woman was self composed, and went through the ordeal apparently with little uneasiness, though her face was not without the expression of trouble."[67]

At the hearing, a co-worker of the victim testified that Jones was not intimately involved with Ella Storer and that he did not live with her but was simply an "old acquaintance." He said that Jones was an "innofensive [*sic*], sober, hard-working man and a gentleman."[68] He corroborated Ella's story that, while she was married to Marmaduke Switzer, he "took no care of his wife, and that she had to support herself and children."[69] He claimed to know this "from his own knowledge of the Switzer family."

Ella herself testified that she'd been living in Golden about three weeks. She also admitted that on the Sunday evening before the shooting, she and Theodore had become engaged to be married.

About six weeks after the shooting, public opinion shifted noticeably in favor of Switzer. Several sympathetic notices about him appeared in the *Colorado Transcript*. The first was a column about Dr. J.G. Rishel of Lewis, Iowa. Dr. Rishel was the brother-in-law of Switzer, married to Marmaduke's sister, Almira. He had come to Colorado for the express purpose of arranging Marmaduke's defense and had hired attorneys Smith & Austin of Denver. Dr. Rishel made a point to visit the *Colorado Transcript* offices to introduce himself and give testimony on behalf of Switzer. He praised Switzer's character and brought along a letter written by a well-known former Colorado pioneer who had moved to Iowa and become a prosperous farmer there: Honorable H.J. Graban.

In the letter, Mr. Graban stated that Marmaduke Switzer had lived with him beginning at age seventeen until the time he left for Colorado, including the period of his marriage and birth of his children. Graban wrote: "I am certain he must have good cause, or he would not have undertaken to defend his honor and right the wrongs he may have received in the way he did."[70]

The *Transcript* article went on to state that Switzer was highly respected back in Iowa, as evidenced by the large number of letters received by the newspaper on his behalf.

THE TRIAL

About mid-April, Switzer's case came before the judge in Golden. Ella Storer did not appear at the hearing. At that time, Switzer's two attorneys were dismissed, and the case was taken over by General S.E. Browne, another prominent Colorado pioneer.

Browne immediately requested a change of venue, which was granted, and Switzer's trial was moved to Boulder with a date of May 21. The defendant entered a plea of not guilty by reason of insanity.

Public opinion had so shifted in favor of Switzer that the general feeling was that justifiable homicide would have been a better defense. By this time, the idea of hanging Switzer seemed outrageous in the court of public opinion, as he "simply did just what any man should have done," as the *Boulder News and Courier* said, "although he put it off longer than he should."[71]

During the trial, the prosecution called the numerous witnesses who had seen the shooting. The defense produced a series of witnesses whose combined testimony painted a picture of a Marmaduke Switzer who was a hardworking, clear-headed and steady man who used to be of jolly disposition before the troubles in his marriage began. Once Jones came on the scene and after the subsequent divorce, Switzer showed increasing signs of insanity, talking to a portrait of his partner and jumping out of bed in the middle of the night, screaming that people were in the room trying to get him. One woman described him jerking about and "us[ing] his eyes in a peculiar way."[72] All of them declared that Switzer had been a changed man, often almost catatonic from depression since his divorce. Several witnesses recounted conversations with Switzer in which he talked about how Jones had destroyed his family. Another witness, Warren Brown, whose brother built Boulder's first courthouse, testified that he was close

friends with Switzer and had warned him about his wife's infidelity. He said that Switzer took a long time to accept that his wife was unfaithful and that after the divorce Switzer was so preoccupied he was unable to work at all.

Switzer's sister, Almira, and her husband, Dr. Rishel, testified that insanity ran in the Switzer family. They described another Switzer sister who had gone insane with symptoms similar to Marmaduke's. Ella Storer's own brother, Taylor Storer, testified on behalf of Marmaduke Switzer, who was his friend. He agreed that Jones had ruined the marriage and even "produced and identified" several love letters that Theodore Jones had written to Ella. These letters, printed in the *Daily Rocky Mountain News*,[73] showed that a romantic relationship existed between Theodore and Ella before she divorced her husband.

The prosecution pressed Taylor Storer to admit that he had recently quarreled with his sister, but he refused to say that he was testifying to get revenge. They brought out a train of doctors who had examined Switzer and declared him perfectly sane. Other people who had encountered Switzer also testified that he seemed normal to them.

While the defense presented its case, Marmaduke Switzer sat quietly in the courtroom. He did not speak to his attorney but occasionally wept. On the second day of the trial, the *Rocky Mountain News* reporter wrote that Switzer had obviously spent the previous night crying.

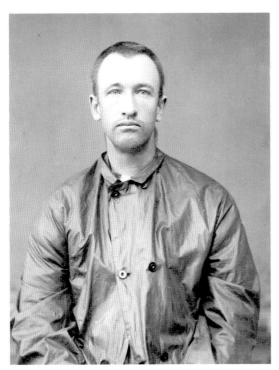

Prisoner no. 903, the unhappy Marmaduke Switzer. *Colorado State Archives.*

THE PUNISHMENT

With this contrary mixture of testimony, the jury went off to deliberate. They returned after only two

Crime: _____ Murder.
From: _____ Boulder Co.
Convicted: _____ May 29th 1883.
Term: _____ Life.

_____ Description. _____

Age: _____ 32 Years.
Height: _____ 5 ft. 8¾ in.
Complexion: _____ Light.
Eyes: _____ Blue.
Hair: _____ Light.
Occupation: _____ Painter.
Where Born: _____ Penn?

_____ Marks. etc.

Scar over right eye. Cut on 1 joint of right thumb. Cut on inside of left thumb.

Record of Convict for
Marmaduke Switzer.
Colorado State Archives.

hours. On May 29, 1883, the jury found Switzer guilty of murder in the second degree, for which the sentence was life in prison.

On June 1, 1883, Marmaduke P. Switzer was received at the Colorado State Penitentiary in Cañon City as prisoner no. 903. The governor of Colorado later commuted his sentence to eight years. Marmaduke Switzer was released from prison on August 2, 1888, after serving a little over five years.

Census records for 1900 show a forty-six-year old M.P. Switzer, a printer born in Pennsylvania, living as an inmate at Terrel Ward 2, North Texas Hospital for the Insane in Kaufman, Texas. The records state that he is widowed.

A Clash over Cucumbers
(1881)

In late August 1881, at the height of the great cucumber harvest, two men farming some land on Bear Creek squared off over a patch of the prickly green fruit. John Berki and Peter Spink had leased a portion of the 160-acre Jacob Gregory ranch, located about twelve miles from Golden at the seven-mile marker on Bear Creek Road. Spink was a fifty-year-old Canadian with a family, who had been in Colorado a couple of years. He was with the firm Spink & Upton at Wewatta and Twenty-first Streets in Denver, producers of cider and vinegar. Berki was thirty-five years old and single.

According to Spink, everything was rosy until harvest time. He said that they had agreed to take turns harvesting the cucumber field on alternating weeks, but when he arrived to bring in his own share, Berki refused to let him take any cucumbers. Spink went back to Denver and consulted with a lawyer, who told him to march back to the patch and assert his rights to those cucumbers. (It's unknown how much the lawyer charged for that advice.)

In Berki's version of the story, Spink had lost interest in their garden when they went through a long period without rain. Berki continued caring for it until it was rejuvenated by the return of wet weather. When harvest time came, he brought Spink four loads of his own accord and considered the rest of it as belonging to him since he did most of the work.

When Spink returned to assert his rights to the cucumbers, he brought reinforcements in the form of a group of men and a gun. As the men pulled up in their wagon, Berki was out working among the cucumbers. When he spotted the group, he went into the house, emerging a minute later with a double-barreled shotgun. One of Spink's comrades, Charlie Upton, the son of his

partner, said later that Berki was putting cartridges into his pockets. Fifteen-year-old Charlie told a reporter that Berki readied his shotgun and announced, "The first man that picks a cucumber will die!"[74]

According to Spink and company, Berki raised his gun first, but Spink beat him to it, shooting Berki in the arm. Berki turned away momentarily, clutching his arm, and then swung back. Spink fired again.

Berki fell to his knees, shouting at Spink to stop. Spink and his comrades fled the scene, presumably sans the controversial cucumbers. Charlie Upton said that they left a man there to watch over Berki while they found a doctor to go tend to him.

It's not clear whether Spink turned himself in or whether a deputy hunted him down. Either way, "General" Dave Cook in

"Cucumis sativus vulgaris, cucumern," from *De Historia Stirpium* by Leonhart Fuchs (1542). *Library of Congress, Prints & Photographs Division.*

Denver put Spink under arrest. Jefferson County sheriff Todd picked up the cucumber shooter and brought him back to jail in Golden.

When Dr. Wohlgesinger examined Berki, he determined that the second bullet entered the body between the sixth and seventh ribs and then passed into his right lung. Luckily for all involved, Berki recovered from his injuries. There is no record of a trial or prison sentence for Peter Spink and no information about who ended up with the cucumbers.

The Missing
Wagonmaster (1879)

Fifty-three-year-old Reuben B. Hayward ranched some property up in an area called Big Hill (the old name for Floyd Hill), in the vicinity of today's Bergen Park. He lived with his wife and two little girls, fifteen-year-old Cora and thirteen-year-old Minnie.

On Wednesday, September 10, 1879, two men approached Hayward's place and hired him to carry them to a cattle camp at a location called Rooney's. Reuben Hayward hitched up his team and the trio took off, with Mr. Hayward's wife and daughters waving goodbye. At about 6:30 p.m., the wagon passed through the Mount Vernon tollgate (located near where State Highway 26 intersects with I-70 at the bottom of Floyd Hill).

Reuben Hayward and his wagon and team of horse mules then disappeared. When Mrs. Hayward hadn't heard from her husband by the following day, she reported him missing. Searchers combed the mountainous region, but there was no sign of Hayward or his team. Descriptions went out for the two men who had hired the wagonmaster. One was described as a heavy young man about twenty with a light complexion; the other was dark complexioned and tall, with a black mustache and hair.

Two weeks after his disappearance, there was still no sign of Reuben Hayward. The Rocky Mountain Detection Agency was engaged to help in the search, headed up by "General" Dave Cook.

Mrs. Hayward, apparently resigned to the idea that her husband was dead, offered two rewards: $200 for the recovery of the team and $100 for the recovery of her husband's body. Jefferson County supplemented the rewards with another $500, and in mid-October, one month after Hayward's disappearance, Colorado governor Pitkin offered $1,000 reward, for a grand total of $1,800.

No doubt inspired by these handsome rewards, Dave Cook developed a theory involving a couple of scoundrels who had been indulging in a crime spree in the region for the past few months.

A fellow by the name of Joseph Seminole, also known as Seminole Jack, had come up with a creative scheme that sent a Georgetown doctor on a dash through the mountains to tend to someone in Hot Sulphur Springs who was gravely ill. Seminole told the doctor to swap out his fine horse for a sturdy mule at a certain ranch. The good doctor followed all instructions only to discover at the end of his arduous journey that nobody was ill. When he returned to fetch his fine horse, he was told that Seminole had absconded with the animal.

Seminole next appeared in Leadville, this time in company with a young man called Tom Johnson, also known as Samuel Woodruff. They hired a couple of horses and took off in the direction of Georgetown. On the way, they encountered a fellow traveler whom they tried to rob. Unfortunately for them, the man was a tough cuss and fought back, sending the two scampering. The man notified the Clear Creek County sheriff's office, who caught the scent of the outlaws and chased them through the woods. There the officers eventually found the two abandoned horses, which were returned to the owners in Leadville.

The busy duo next hijacked a man named Anderson and his rig, but when a group of wagons approached on the road, the two men abandoned their latest prey and scurried off again into the forest.

On September 11, these same men rented two bay mares and a buggy from a place on Arapahoe Street in Denver. When they had not returned by that evening, the proprietors notified the Rocky Mountain Detection Agency, which sent out the alarm. The next morning, the buggy was found abandoned in Loveland, but the horses were missing.

Dave Cook suspected that these two culprits were the same fellows who had disappeared with Reuben Hayward and his rig. Hayward had been hired immediately after the incident with Anderson, in the same area.

About the time the rewards were announced, a man named Robert Jackson was walking from Golden to Denver along the South Golden Road. He stopped to refresh himself in a small stream by the roadside, and as he stooped over to scoop up a handful of water, he noticed something poking out of the mud in the culvert that crossed under the road. Upon closer inspection, he found a human being lying on his back, cramped up, with the back of his hand over his face. The man was covered with mud and had been dead for several weeks.

The coroner determined that the man was Reuben Benton Hayward and that he had died from a severe blow made by a blunt instrument from behind. His neck was broken.

Cook sent one of his detectives up to Loveland to see if he could pick up a trail from the spot where the thieves had abandoned the buggy they rented in Denver. Sure enough, two men matching their description had been sighted in Larimer County, heading in the direction of Cheyenne.

Detectives also uncovered some background information about one of the fugitives. The older of the two, Seminole Jack, was half Sioux and was known to have family up at the Pine Ridge Reservation in South Dakota.

Cook sent one of his men, Mr. Ayres, into the Dakotas to find Seminole Jack. This was not an easy task. The Pine Ridge Reservation was almost 350 miles from Denver—a long rugged journey by horse and stagecoach. Thinking that the Sioux would not hand over one of their own if they thought he might be hanged, Cook told Ayres that Seminole was wanted for being a horse thief and not a murderer.

When Ayres arrived at Pine Ridge, he approached authorities there, showing them evidence of the stock thefts. The tribal police—none too fond of horse thieves themselves—quickly led the detective to the man's home. When the officers went into the house, Seminole resisted arrest, kicking and fighting. Ayres and the tribal officers wrestled him outside, finally throwing him into the dirt and handcuffing him. Ayres then hired several Sioux men to help him escort Seminole back to Denver.

The journey back with the prisoner was uneventful until they boarded the train in Cheyenne. At some point during this trip, his guards having fallen asleep, Seminole managed to jump off the moving train. He ran in his shackles through the wilderness for some days before being caught.

Once Seminole was safely ensconced in jail in Colorado, Cook went to work on him. When Seminole asked for a lawyer, Cook, unencumbered by pesky Miranda regulations, sent in a detective posing as a legal adviser. This officer tricked Seminole into revealing all he knew about the killing of Hayward and the current whereabouts of his partner, Woodruff.

As is often the case, Seminole provided ample details about the misdeeds committed by his partner but painted his own role as that of a bystander. He said that as they rode along in Hayward's wagon, Woodruff was sitting in the back. Suddenly, Woodruff attacked the older man from behind, hitting him in the neck and strangling him. While Seminole handled the reins, Woodruff heaved Hayward out of the wagon just as they crossed over the culvert on the Golden Road.

The two men drove into Denver, where they sold Hayward's rig. They rented the horse and buggy and hightailed it out of town, heading north to the Wyoming border. Seminole told his "attorney" that when they parted, Woodruff was going toward the Niobrara River in Nebraska.

Once they had this confession, Cook sent two men, Mr. Ayres and Mr. Hawley, into Nebraska to search for the second killer of Reuben Hayward. It didn't take them long to locate a fellow called Tom Johnson—Woodruff's alias—who ran off when they confronted him. After a weeklong chase, they nabbed the guy and dragged him back to Denver. Unfortunately, he proved to be the wrong man, though he turned out to be a horse thief as well. This second Tom Johnson was turned over to authorities in Omaha, and our detectives were once again at square one.

Their luck returned when they learned that Woodruff had relatives somewhere around Council Bluffs, Iowa, or Omaha, Nebraska—two cities located next to each other. Hawley headed to the area and nosed around, posing as a granger looking for work. He finally found information about a man named James W. Woodruff who lived at Big Grove, Nebraska. James had a brother named Sam.

Hawley went to Big Grove and got himself a job as a corn husker at the farm next door to the Woodruff place. As he husked corn, he learned that Sam Woodruff had showed up about ten days earlier and had opened a $9,000 bank account in town.

Certain that he'd found his man, Hawley returned to Council Bluffs, where he got an arrest warrant for Sam Woodruff. He and a local constable rode back to the Woodruff place, where they discovered that the Woodruffs had moved into town. In Big Grove, the lawmen soon spotted the Woodruff brothers, who also seemed to have spotted them. After a brief cat-and-mouse game, Hawley confronted the brothers with a double-barreled shotgun and the announcement that was common in those days: "Sam Woodruff, throw up your hands; I want you."[75]

Woodruff made some motions to draw a weapon, but Hawley quietly convinced him not to. The constable handcuffed and shackled him, and they carried him off to jail in Omaha. The next day, Detective Hawley escorted Woodruff to the train to Cheyenne, and from there they caught a stage to Denver.

Now that they had the two in custody, Cook invited Mrs. Hayward and her daughters, Minnie and Cora, to come to the jailhouse and see if they recognized the prisoners. All three had been present when Reuben Hayward discussed his terms with the men. The three positively identified

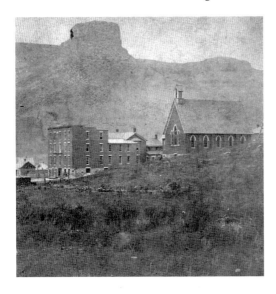

1870s Golden. The unfinished building on the left is probably the original courthouse and jail from which several prisoners were prematurely extracted by mobs. *Library of Congress, Prints & Photographs Division.*

Woodruff and Seminole as the men who had gone off that day with their father and husband.

The Hayward case had become a local sensation, and great crowds formed when the prisoners were brought in for their preliminary hearing on December 9 and their arraignment on December 26, 1879. The judge ordered that a trial begin the next year.

Naturally, there was much talk of lynching. Jefferson County sheriff Belcher took great precautions when moving the two prisoners from the Arapahoe County Jail in Denver to the jailhouse in Golden City.

On the night of December 28, just when the jailers thought things had settled down and they could relax a bit, a large number of masked horsemen rode silently through the quiet streets. It was about midnight. The men surrounded the courthouse, which also contained the jail. Someone climbed a pole and cut the telegraph wire.

Inside, Undersheriff Boyd and Edgar Cox, the watchman, were sleeping. Cox heard a noise. He got up and looked out the window, only to find several pairs of eyes glaring in at him through the glass—plus several gunbarrels aimed at his face.

He froze. Behind him, there was the heavy sound of many men's footsteps as they entered the building and headed down the stairs to the jail area. Soon a banging and clanking rose as the men broke down the door into the jail cell.

By now, Undersheriff Boyd had appeared, having been awakened by the racket. The masked men kept their guns trained on Boyd and Cox. Boyd

tried to talk them out of it, but the men ignored him. They soon broke into Woodruff's cell. Woodruff tried to fight them off, but the skirmish ended quickly when someone rapped him in the head with a rifle butt. They carried him out of his cell, throwing him face down onto the ground and binding his wrists behind his back. He gave a feeble protest, appealing to the "gentlemen" that he was innocent until proven guilty. Finally giving up, Woodruff asked Boyd to write to his family and tell them what happened to him.

Meanwhile, the abductors broke into Seminole's cell. After some initial howling, he went quietly.

The mob took the two prisoners out of the courthouse's basement door and went through the moonlit night toward a train trestle on the Golden and South Platte railroad. The trestle, torn down long ago, was located three to four hundred yards from the courthouse, along Kenney's Creek in the area between today's Jackson and East Streets and Thirteenth and Fifteenth Streets.

Woodruff refused to walk, so they dragged him. Seminole walked. Once on the trestle, the men placed nooses around the two prisoners' necks. They asked Woodruff if he had anything to say. He said a prayer and then asked for permission to jump off the trestle himself instead of being pushed. However, he hesitated too long, and a dozen hands suddenly shoved him into the abyss. Unfortunately for Woodruff, the fall did not break his neck, and he did not die right away. After about five minutes of watching the man choke at the end of his rope, several of the lynch mob went down into

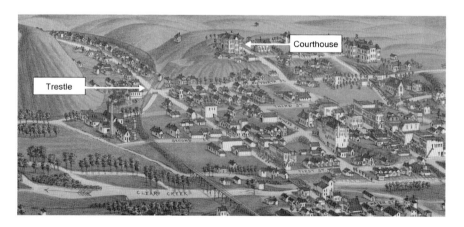

Detail from *Bird's Eye View of Golden, Colo.* (1882), showing location of the courthouse and the trestle where the mob took Seminole and Woodruff. *Library of Congress, Geography and Map Division.*

the gully. There, Woodruff dangled only a couple feet above the ground, still alive and making terrible sounds and contortions. The men lifted him, messed with his rope and dropped him again. This action seemed to do the trick, and Woodruff stopped moving.

At this point, at least one of the mob had enough of the ugly business and claimed that he couldn't watch another moment of it. However, the job was only half done. Up on the trestle, Seminole was ordered to say his last words. He told a brief tale describing his unfortunate descent into criminal behavior and then confessed to the crime of murdering Hayward. He said that he had no excuses to offer and then made a prayer that was touching enough that his executioners removed their hats and listened in grave silence.

Then they shoved Seminole off the trestle. Luckier than his partner, Seminole died immediately of a broken neck.

Meanwhile, Sheriff Belcher had been dragged out of bed and was on his way. By the time he arrived, a lone man stood guard over the dangling bodies.

Eyewitnesses reported that there were between one and two hundred men in the mob. Little effort was made to find out who they were. The coroner came to view the bodies, and the dead men were cut down. An express wagon arrived and carried the bodies away to an empty storeroom on Ford Street. After the inquest, no family members came to claim the bodies, so Seminole and Woodruff were buried in the Golden cemetery. The exact location of their graves is unknown.

Reuben Hayward and his wife are also buried at the Golden Cemetery, but their markers, if any, have vanished.

The Peculiar Case of Mary Cobb (1910)

In a small, isolated cabin near the forgotten settlement of Midway, a fifty-two-year-old widow named Mary Susan Cobb was found lying on the floor of her kitchen. A thin cotton "lap robe" was wound around her neck, and a quilt covered her face.

The date was Saturday, March 26, 1910. The Cobb ranch was situated close enough to Henry Lake (at Carr Street and Colorado Road 44) to have water rights to the lake. Today a part of Lakewood, at that time the area was rural. The closest village was Midway, located near today's intersection of Wadsworth and West Jewell Avenue.

Mrs. Cobb was discovered by her brother, sixty-seven-year-old Bert Hodge, who shared the cabin with her. When Jefferson County deputy sheriff Etchley (or Atchley) arrived, Bert explained that he'd been out for a short walk and found his sister when he returned. He claimed that she was still alive and gasping for breath when he found her, so he tried to revive her. During this process, he looked out the window and spotted Marion Shobe driving up the road to their cabin. Marion was a thirty-one-year-old black man who worked for Mrs. Cobb. When Marion came in, Bert sent him to the neighbor's place to call the sheriff.

By the time Deputy Sheriff Etchley arrived, Mary Cobb was dead, and several neighbors were milling around at the cabin. Etchley called in Dr. Grieger from Englewood, who noted blue marks on Mrs. Cobb's neck and an injury on her back. He speculated that someone had used a rope or other type of band to strangle her and that the deep bruises on the back of her neck had been caused by the killer's knuckles as he squeezed the life out of her. Dr. Grieger said that suicide was out of the question.

Two boxes of strychnine tablets were found next to the body, and Bert indicated that his sister took the medicine on a regular basis. Because of the strychnine, the coroner decided to do an autopsy.

Meanwhile, based on statements made by Bert Hodge, Etchley arrested Marion Shobe.

At the turn of the century, Mary Cobb and her husband William had been hotel keepers in Lindsey, Missouri. They had a fourteen-year-old daughter and a couple of servants, one of whom was Marion Shobe. At some point during the next decade, the couple moved to Colorado, bringing Marion with them. William Cobb died in 1909. According to Marion, he had an agreement with Mary that he would inherit the ranch if he would work for her without pay. After William Cobb's death, Mrs. Cobb asked her elder brother, Bert Hodge, to move in with them. Bert Hodge and Marion Shobe did not get along.

The autopsy did not find enough strychnine to have caused Mrs. Cobb's death. On Tuesday, the coroner held an inquest. Not for the last time, Bert Hodge's story shifted. Now he testified that on the morning of the murder he'd been sitting on the porch of the cabin, listening to his sister and Shobe fight about money. Finally, he took off for a walk. Although he was described as "feeble," Bert said he walked for an hour and a half. When he returned, he found his sister on the kitchen floor. He claimed that it wasn't unusual for her to pass out. He said she often clutched at her throat and had heart trouble and other problems related to her drinking.

Bert's testimony aroused the suspicion of investigators. There were inconsistencies in the timing of events, and some details did not fit what he said earlier.

Marion Shobe's testimony didn't match Bert's. He said that he'd been shopping in Midway for a couple of hours and returned after Bert had found Mary's body. He seemed to think that he'd been arrested for theft rather than murder. He denied all knowledge of the killing but admitted that once he realized that Mary was dead, he had gone through the house and collected all the money he could find, saying that Mary had not paid him any wages and that he didn't want Bert to get hold of it.

Later, witnesses from Midway said that Marion had only been there for about ten minutes. They said that he had purchased gun cartridges while in the village and recounted a threatening remark he'd made, along the lines of, "That old fellow's got to go," apparently referring to Bert Hodge.

Another fact soon came to light that did not help Marion's case: he had previously served two years in a Missouri penitentiary for taking part in a "cutting affray," the old term for a knife fight.

At the end of the inquest, the coroner's jury ruled that they could not determine what happened to Mrs. Cobb, except that some unknown party had strangled her. Sheriff Heater kept Marion Shobe in custody while he investigated further. For good measure, he arrested Bert Hodge as well.

Newspapers were soon reporting that the household was a boozy one, with one unsubstantiated rumor going around about a "drunken orgy" the night before the murder.

The preliminary hearing was scheduled for a few weeks later. During the interim, two young boys came forward with information. They described a fight they had witnessed between Mary Cobb and Marion Shobe a year earlier, during which Marion Shobe had threatened Mrs. Cobb with a razor. The testimony became a major part of the prosecution's case, despite the fact that the boys were the sons of Deputy Sheriff Etchley, the lawman who arrested Shobe in the first place. (The 1910 census lists a Bert Hodge as a boarder with the Etchley family.)

Bert Hodge gave another statement at the preliminary hearing, but his story had become even more muddled and did not help things one way or another. Marion Shobe refused to speak at this hearing. He said that he would speak his mind when his trial took place in the district court, set for early June.

Bert was let go.

Shobe's trial in Golden had hardly begun when his attorneys, Mr. McCall and Mr. Stuart, moved that the case be dismissed and their client be ruled not guilty. This came about after the prosecution's first witness, Dr. Grieger, gave his testimony about the condition of Mary Cobb's body when he examined it. The judge questioned the doctor rigorously, trying to ascertain what led him to conclude that she had been murdered. He then asked for a statement from the district attorney outlining the case he had against Shobe. After hearing the district attorney's statement, the judge ruled that there was no evidence that Mary Cobb had died at the hands of another. He dismissed the case, and Marion Shobe walked out of the courtroom a free man.

Marion Shobe did not inherit Mary Cobb's ranch as she had promised. That September, the administrator of her estate published a notice for the sale of her ranch, the proceeds of which would go to pay her debts. The 1920 census shows Marion Shobe working as a laborer for a family of Russian immigrants on a Commerce City farm.

A Horse with Only One Shoe (1884)

The rumor going around about the elderly Shaffer's Crossing couple being poisoned turned out to be someone's complete fabrication. The fact was that Robert and Marie Standring had been shot.

It happened on or about Sunday, November 9, 1884, on the Standring ranch on Elk Creek. Some speculated that it was a robbery. The couple had just sold their ranch for $30,000 and likely had cash around the house.

On the other hand, Robert Standring was an irascible character, hated by more than a couple neighbors. A sixty-year-old native of Scotland who had been a "fifty-niner" in frontier Colorado, Standring was embroiled in several lawsuits. There were plenty of motives to go around.

A week after the Standrings were found dead in their house, Jefferson County sheriff Nichols arrested a local man named John M. Carrothers for the murders. Old man Carrothers was tangled in a dispute with Standring, and there was said to be circumstantial evidence against him related to a horse with one shoe.

Despite the arrest, other rumors and theories continued to flow wildly throughout the valley: the couple had been done in by a mysterious heir to the Standring estate; several of Standring's other neighbors wanted him dead; and a destitute local had suddenly purchased a saloon in Denver. Those who knew "Uncle John" Carrothers described him as a boastful fellow who "had not the heart of a chicken."[76] He may have hated Mr. Standring, they said, but he wasn't the type to kill a woman.

The most compelling tale traveling from ear to ear was about Marie Standring's first husband. The *Fairplay Flume* had his name as Newcomb, but Colorado marriage records show a Marie Newman marrying Robert

Standring in 1870. Mr. Newman was the original owner of the ranch where the Standrings lived. He was described as "a man of fierce and brutal temperament."[77] Seventeen years earlier, he had gone into a fit of rage, beat up Mrs. Newman, hitched two yoke of oxen to a wagon full of potatoes and disappeared over the horizon. He never returned.

At the time of Newman's disappearance, Mr. Standring was a boarder at the ranch. Three years later, Marie Newman had secured a divorce from her vanished husband and, on April 19, 1870, married Mr. Standring.

Some said that Newman had returned with vengeance on his mind.

In February 1885, Carrothers had a preliminary hearing in Golden. He claimed an alibi—he'd been eight miles away from the scene of the crime and had witnesses to prove it.

A neighbor of the Standrings, J.W. Burke, testified about discovering the bodies. He found tracks on the hillside near the home, apparently of two or three men, and found bloodstains on the outside of the front door.

He reported a peculiar note found inside the house: "I went out of doors, want Carrothers."[78] Oddly, the first portion of the note, "I went out of doors," was written in ink and the rest of it was written in pencil.

One of the investigators on the scene, Peter L. Case, testified about horse tracks he found near the ranch house:

> *They were the tracks of a horse with only one shoe; the foot with the shoe was very distinct, and the shoe was old. I should think that the horse traveled slow on the road, but was making good time near the premises; the track left the Clifford road; I followed the track until it went down toward Ramsey's ranch and I found a shoe, about three-quarters of a mile from Crawford's ranch. From there the track came back. It was a bare-footed track after the place where I found the shoe.*[79]

Carrothers's horse had been found to be shoeless, and a gun was discovered in his cabin. One expert said that he thought it had been fired recently, but another said it had not.

A local man named Thomas Jordan claimed to have information about the case. Described as a fellow who had "sobered up in time to testify,"[80] Jordan said:

> *I knew Mr. and Mrs. Standring since 1876. I knew Carrothers a little; I saw him down by a saw mill about election day. I'd bought a bottle of whiskey and went down there to drink, and I see Carrothers; I asked him*

to drink, and he did. Then he spoke about some trouble which he had some years ago, and then he spoke of the "Standring outfit." He said he thought that he'd lose his ranch after the court met next spring. Then he said: "Tom, what'll you take to come up and hunt with me a while? I'll give any man $1,000 to get away with that Standring outfit, so I can save my ranch." He said, "I've had my eye on the s-n of a b---h and been tempted to put his light out a good many times, but I thought it would do no good, as the old woman would hold the mortgage anyhow." [81]

A saloon keeper in Pine Grove named Robert McCoy said that Carrothers had been in his saloon drinking and bragging that he'd "get even with Standring."[82]

Defense witnesses were also called. One man said that he'd bought hay from Carrothers on Monday, the day after the murders had probably been committed. This story accounted for a wad of money that Carrothers had in his pocket that day. Charles Nelson, a local rancher, said that he saw Carrothers that Monday as well. Nelson testified that Carrothers only had the one horse, which had never been shod. He said the horse was lame and could not be ridden.

Other witnesses questioned the Jordan testimony, suggesting that he was lying. A man named Charles Nickerson said that Jordan told him, "I don't know anything about this case, but if I go onto the stand I'll tell a h-ll of a sight."[83]

Carrothers himself, who was limping about with a broken leg, testified that he was at his ranch for most of the day of the murder. In the afternoon, he went to Nelson's, then to Nickerson's and then back to Nelson's. The next day, he went to Denver, where he "got full of beer had a struggle with a man and got his leg broken."[84] He heard about the murder when he was in the hospital. The gun found in his cabin belonged to a young man named Willie Kelso, who was at that time in a Fairplay jail for passing a counterfeit half-dollar. Carrothers denied having the conversation described by Jordan.

The judge decided that the prosecutors had a strong circumstantial case against Carrothers, and he was held on $5,000 bond.

On Friday, April 17, 1885, a grand jury met but failed to indict Carrothers. His alibi was considered strong, and they were unable to make the other evidence stick. After spending six months in jail, Carrothers was released.

The citizens of Pine Grove requested that Colorado governor Eaton put up a reward of at least $1,000 for the apprehension of the murderers. A reward of $650 was eventually offered. The *Fairplay Flume* published a long

column decrying the "clumsy" work of investigators, who had ignored other possibilities in their dogged pursuit of Carrothers, including the mysterious Mr. Newman and Willie Kelso, the boy who owned the gun found in Carrothers's cabin.[85] A week later, the *Fairplay Flume* published a letter to the editor written by the prominent ranchman William L. Bailey, after whom the town of Bailey is named. He decried the aspersions cast on young Willie Kelso. He claimed that the boy was a good lad and loved by all, despite being in jail for passing a counterfeit half-dollar, which he probably didn't realize.

In May 1885, Robert Standring's brother arrived in town from Scotland, saying that he was determined to find out who murdered his brother, but his efforts bore no fruit. The Standring murders were never solved.

The Mystery of the Crescent Postmaster (1918)

Described as a "lonely mountain station," the Crescent Post Office and general store in 1918 served a scattered and remote community of hardy mountain dwellers. Today, Crescent is little more than a wind-swept meadow southeast of Gross Reservoir. Near a trailhead for the Walker Ranch Loop Hike, the area is occupied by elk, deer, bears and mountain lions, along with hikers and a few mountains homes tucked away among the pine trees.

On February 22, 1918, a local rancher named August Blumm (or Broom) stopped by the small building occupied by the Crescent postmaster, Fred E. Bill (or Bills). Blumm was startled to find twenty-five-year-old Bill dead inside. He had been shot in the head and had apparently been lying undiscovered in his kitchen for several days.

For the next nine weeks, the identity of the killer and the motive remained a mystery. Although Crescent is across the county line in Boulder County, Jefferson County sheriff Jones and Boulder County sheriff R.L. Euler worked on the case together, with help from Detective Leonard DeLue.

The investigators soon zeroed in on one particular suspect—a young local man named Louis Seeley who had shown unusual interest in the case. The Seeleys were well-known Jefferson County pioneers. The large family of five boys and three girls had lived on a ranch in Coal Creek Canyon for many years before moving to Golden in 1913. Young Louis lived in Golden with his parents, William and Florence, but had a reputation for spending long periods of time by himself up at the old Coal Creek ranch. There he passed his days wandering the favorite haunts of his childhood and hunting.

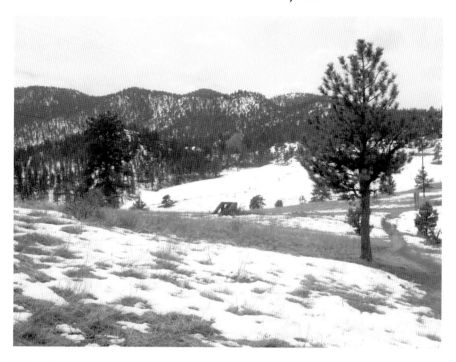

Today, Crescent is a pretty meadow with only a few remaining hints that a settlement once existed here. *Photo by the author.*

Louis had gained attention one May day in 1914 when he headed alone up to the family ranch on Coal Creek to take care of some horses. As he arrived, he noticed that the house door was open. According to Louis, he entered the house and discovered that two bearded men armed with automatics had occupied the place. The men told the young Louis to "beat it." He went to a neighbor's ranch, where he called his father and brothers in Golden. Having no other way to get up the canyon, the two brothers set out on foot as a storm moved in. Meanwhile, Louis picked up a rifle and ammunition and returned to the Seeley ranch by himself, arriving at ten o'clock that night. His barking dogs gave him away, and the bearded men burst out the front door and began shooting at him in the darkness. Louis found shelter behind a post and returned fire. During the gun battle, Louis says that one of the men fell but got up again, and the two squatters ran off into the forest. Louis later found a bullet hole in his collar.

His two brothers, after walking seventeen miles through the storm, arrived at four o'clock in the morning, having missed all of the action. No one doubted Louis's story and it made the local papers.

Four years later, a somewhat less heroic Louis Seeley called attention to himself again, this time during the investigation into Fred Bill's death. He approached the detectives and offered unsolicited theories about who the murderer might be. Despite several grillings, Seeley denied any involvement.

Within a couple of months, however, Seeley made a mistake. He went to a pawnshop in Denver and pawned a watch belonging to Fred Bill. The police had been monitoring pawn shops for items missing from Bill's place, and Seeley was immediately arrested. During a long interrogation, Seeley refused to confess until he somehow got the idea that he would hang if he didn't fess up. Begging for a promise that he wouldn't be treated to a date with a rope, he produced a dozen typewritten pages worth of confession.

He told the officers that on the afternoon in question, he left the Coal Creek ranch for a hunting trip at 2:30 p.m. and hiked through the mountains to the Crescent area. When he was about half an hour away from Crescent, suddenly "the notion to kill Bill just came into my head," he said.[86] He couldn't explain where the impulse came from or why, though he admitted that he had argued recently over mail with the postmaster. The officers heard rumors from other sources that Seeley was romantically entangled with a mysterious widow who lived in the area and that Fred Bill had somehow become an obstacle in this relationship.

In his confession, Seeley described an eerie scene: as he contemplated his act of murder, he stood on a hillside behind Bill's store, holding his 30-40 Krag-Jørgensen rifle. He was "watching Bill through the window and waiting for Bill to turn around."[87] The conscientious Seeley did not want to shoot Bill in the back.

When Bill turned around, Seeley pulled the trigger and watched his victim drop. Afterward, he hiked down the hill and spent an hour sitting on the railroad tracks. He claimed that he was immediately sorry for what he'd done and that he passed this time trying to figure out what to do.

After this period of soul-searching, Seeley headed down to the store and climbed in through a window. Despite his angst, he made a beeline for an iron chest, where he knew Bill kept his money. He broke it open and removed eighty-four dollars along with Bill's revolver. He found Bill's gold watch on a shelf and pocketed that as well.

The next day, he left the family ranch and headed down to the home of his unsuspecting folks in Golden. When he testified during his trial, he stated that he then used the stolen money to travel to Williamsburg, Illinois. He apparently did not last long there and was soon back in Colorado, living with his parents, working at a shooting gallery in Denver and lurking around the investigation into Fred Bill's murder.

After confessing, Seeley was taken to Boulder County Jail to await trial. A week later, he suffered an acute case of appendicitis. He had his appendix removed and spent two weeks in the hospital, during which time he was chained to his bed and constantly guarded. Upon his recovery, he returned to his jail cell. His trial was set for May 31.

Despite this delay, Seeley's trial was speedily administered. His attorneys built a defense based on the fact that Seeley had lived a solitary life since the age of ten, roaming the mountains with his rifle and only rarely engaging with his fellow humans. While the district attorney admitted that Seeley was "different from the average man," he exhorted the jurors not to let the defense play too much on their sympathies. He pointed out that Seeley had already been cut a break when they did not ask for the death penalty.

Seeley showed no reaction when he was found guilty of second-degree murder. Probably as part of the deal that spared the young man his life, his defense team declined to file for a new trial and made no objection to the judge's maximum sentence of twenty-five to life. Although Seeley's parents were not in the courtroom, one of his sisters, Mrs. Mattie Wyckoff, stood by quietly as the judge pronounced sentence. Earlier, when the attorneys made their final arguments, she had wept for her brother.

On June 3, 1918, Louis Seeley was received at the state penitentiary in Cañon City. On August 27, 1930, after serving twelve years for the murder of Fred Bill, Seeley was paroled. His freedom was short-lived. In April 1932,

```
10528, Louis Seeley, Recd. 6-3-18, Boulder,
Murder, 25 to Life, age 22, weight 160, height
5-10, complexion light, bust 38, waist 33, thigh
21, neck 15, hat 7-5/8, shoes 9, hair light,
bust 38, waist 33, thigh 21, eyes blue,
build medium. Born in Colorado. Nat. American
Occupation Farmer.    Scar on right side of
head.    Scar on back of head.    Teeth in bad
shape.    Bullet wound on left upper arm.
Operation scar on right side.
```

Louis Seeley's Record of Convict. Note the mention of an unexplained bullet wound on his left upper arm. *Colorado State Archives.*

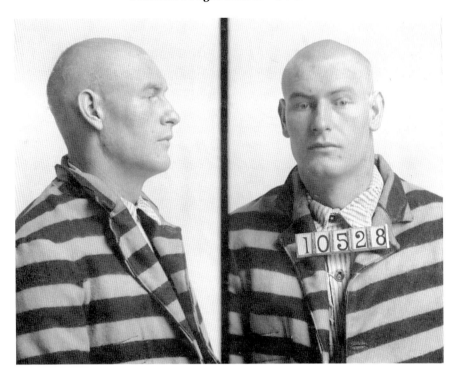

Above: Louis Seeley was only twenty-two when this mug shot was taken. *Colorado State Archives.*

Left: The Seeley family plot at Golden Cemetery. The blank spot is where Louis is buried. *Photo by the author.*

he was arrested and convicted of larceny and sent back to prison with a sentence of four to six years. Once again, he was paroled on March 4, 1934 after serving two years, and his sentence was discharged March 24, 1935.

Seeley still had not learned anything useful from his experiences, and he was back in Cañon City on November 24, 1936, on a charge of burglary with a sentence of three to five years. And once again, he was paroled on October 12, 1938, after serving two years.

Seeley died in February 1950 at the age of fifty-four. He is buried in an unmarked grave in the Seeley family plot at the Golden Cemetery.

A Bully Gets His Due
(1918)

On a cold Sunday morning in 1918, a frightened young man named Ralph York phoned Jefferson County sheriff Jones and told him that he'd shot his brother-in-law and needed help.

The date was January 20, a Sunday night. The place was the Lucas Ranch located near a forgotten village called Semper, in today's Westminster. Once a stage stop on the old Cherokee/Overland trail, the village was founded by Charles Semper, Colorado's first typesetter, who worked on the earliest issues of the *Rocky Mountain News*. Today, the old Semper Farm at Ninety-second Avenue and Pierce Street in Westminster is one of the last remaining buildings from the original settlement.

The summer before the shooting, twenty-year-old Ralph York had moved in with his older sister and her new husband, W.H. Harriman. Harriman was a two-hundred-pound, thirty-five-year-old man with a taste for liquor and violence. The two men worked the ranch together, but according to Ralph, Harriman pocketed all of their income, using a significant portion of it to satisfy his booze habit. Ralph said that even when he did odd jobs for other ranchers in the area, Harriman bullied that money away from the younger man. Ralph and his sister were both terrified of Harriman, particularly after he boasted about having killed two men. Harriman had served time in an Idaho penitentiary and sometimes used an alias, Logan Miller.

The worst part about it, and the source of that night's trouble, was that Harriman had a penchant for beating his twenty-five-year-old wife, described as a "slight little woman." The two had been married only a year.

According to the account given to police by the brother and sister, on the night of the shooting, Harriman had been indulging in a lengthy tantrum

This building was once a roadhouse on the old stagecoach route that went through Semper. *Drawing by Richard Turner.*

around the house. In a drunken rage, he pummeled his wife with his fists and knocked her down. He then picked up an oil lantern and hurled it at her and tried to set the house on fire. Once he exhausted himself in this way, he left the house to catch the train into town, where he intended to get some more whiskey. As he left, he vowed to come back and "clean them up."

After Harriman left, Ralph York and Mrs. Harriman stayed up, waiting for the last train from Denver to come back through Semper. After midnight, Harriman staggered through the gate to the house, obviously drunk. When he tried to open the front door, he discovered that they had locked it. He kicked at the door, screaming and cursing, threatening to "finish him up" when he got in. Ralph ran to the bedroom and picked up Harriman's shotgun, which he always kept loaded. Brother and sister huddled while Harriman continued pounding the door. As the door gradually gave way, Ralph aimed the shotgun. Just as the door was about to open, Ralph fired through the wood. Harriman fell back on the porch.

Ralph ran to a neighbor's home and phoned the sheriff and a doctor. Although the left side of Harriman's face had been blasted away, he was still

alive. They transported him to the Denver county hospital, but a few hours later, early on Monday morning, Harriman died.

On Tuesday, Coroner Woods held an inquest, calling the doctor and the neighbors whom Ralph had contacted after the shooting. After hearing their story, the coroner's jury ruled that the killing was a justifiable homicide. However, the deputy district attorney decided to file murder charges against him anyway and arrested Ralph York.

The wheels of justice turned a bit more quickly in those days, and Ralph York was put on trial two months later. He and his sister repeated the stories they had told the coroner's jury. When all of the testimony was complete, the jury went out for about five minutes before returning with the verdict: Ralph York was found not guilty and was set free.

The Voices Made Him Do It (1920)

On a cold Saturday afternoon, January 17, 1920, rancher J.M. Terry dropped by the house of his foreman, Orrin E. Babcock. The place looked deserted, so he left without thinking much of it.

Located near today's intersection of Kipling and Thirteenth Avenue in Lakewood, in 1920 the region of Terry's property consisted of ranches and farms. Terry grew hay, grain and feed, which he sold at his wholesale business, the J.M. Terry Company on Blake Street in Denver. Though they lived in a rural setting, locals had easy access to Denver and Golden because of the Denver and Interurban tram. The line ran right through the area, with two stations near Terry's ranch: the Bee Hive station, which was about a quarter-mile away from the Babcock place, and Coleridge station, located at today's intersection of Thirteenth Avenue and Nelson Street, about a mile away from Babcock's.

On Monday morning, January 19, Mr. Terry's puzzlement developed into annoyance when he saw that his cows had not been milked and the calves were in the wrong area. He hadn't seen his foreman around for three days. Even more odd was that he hadn't seen Babcock's forty-two-year-old wife, Mary, or their sixteen-year-old son, Vernon.

Terry approached the Babcock house and banged on the door. No one answered. He walked around the side of the house and entered through the kitchen door. There he stumbled over the prone body of Mary Babcock. She lay face down on the kitchen floor, clutching a package of eggs. The walls and ceiling of the kitchen were spattered with blood. Mary's head had been blown apart by the blast of a shotgun.

Terry took a quick look into a bedroom off the kitchen, but a foul smell drove him away. He ran out of the house and to the ranch of a neighbor, where the two men contacted authorities.

Coroner William Woods and Jefferson County sheriff Jones soon arrived at the home. In the bedroom, they found young Vernon Babcock fully clothed in his bed, half his head blown away from a shotgun blast.

The entire house was in a state of disarray, with drawers pulled out and upturned and clothing strewn across the floor. Forty-three-year-old Orrin Babcock was missing.

The next morning, the coroner held an inquest. He ruled that Mary and Vernon had likely been killed the previous Saturday, January 17—forty-eight hours before the bodies were discovered.

Witnesses had seen Mary Babcock shopping on Saturday morning in Denver, and neighbors had spotted her about 11:30 a.m., walking home with her groceries from the Bee Hive tram station. Judging from the position of her body, she had apparently been shot as she entered the house through the kitchen door. When discovered, she was fully clothed, including her hat, gloves, rubbers and coat.

Vernon was lying in his bed when he was killed, fully clothed. Investigators speculated that he may have had his breakfast Saturday morning and then gone back to his room to lie down again. He'd apparently been shot while his mother was in Denver shopping.

During Vernon's autopsy, examiners discovered a rifle ball inside the boy's skull in addition to the shotgun injury. Based on the condition of the head and the blood spatter in the room, the killer had shot him in the head first with a rifle, then placed the muzzle of the shotgun against his head and fired again.

Investigators learned that the night before the killings, the entire family had been seen together coming home from Denver on the last tram car. Police also located a witness, William Gill, who spoke to Orrin Babcock on Saturday afternoon at 1:20 p.m. as Babcock boarded the inbound Intermountain tram at the Coleridge station, a mile away from his regular Bee Hive station. An acquaintance of the family, Gill said that Babcock was carrying a black suitcase. Gill had asked Babcock if he were going away, and Babcock replied that he was returning the suitcase to a friend in Denver, from whom he had borrowed it.

Babcock had apparently walked across the fields to the other station, possibly so no one could see him boarding the tram at Bee Hive. Police found a pair of boots stashed under the Coleridge platform, which they later identified as Babcock's.

Police interviewed friends of the family, who expressed shock at the shootings. The friends said that the Babcocks enjoyed a pleasant home life with little strife, and they could think of no reason why Babcock would kill his wife and son, with whom he had just been out to Denver the night before. The Babcocks had moved to Denver from Kansas about four years earlier. The previous July, Mr. Babcock had taken the job with Mr. Terry, and the family had moved out to the ranch.

One telling story did emerge. Friends of Babcock's told police about an incident back in Kansas five years earlier. They said that Babcock had gone temporarily insane and had been found lying in a haystack—starving and suffering from exposure.

Inside the house, police found a peculiar letter Babcock had written to family members back in Marion, Kansas:

> *Hello folks! Hope you are getting along fine. Having good weather here. I ain't feeling good. I feel so queer in my head. If I don't feel better am going to a Dr. or come up there to be with you folks. I would go over to Dot's but she is alone too now. Guess I will go to bed—will finish in the morning.*[88]

Sheriff Jones issued a warrant for Babcock's arrest. Jones contacted authorities in Marion, asking them to be on the lookout for the fugitive. Managers of the Babcock estate offered a $100 reward for information leading to Babcock's apprehension.

In early February, three weeks after the murders, a peculiar incident took place in Walton, Kansas, north of Wichita. A disheveled-looking man walked into a bank there and asked the teller if he knew a fellow called Ed Lovesee. When the teller said yes, the man came up with this puzzler: "Well, that's me, and I am looking for him. I am Lovesee, where is he?"[89]

After much confusing conversation, the teller finally phoned Mr. Lovesee, who lived in the nearby town of Peabody, Kansas. Lovesee drove over to Walton to see what it was all about and there found his old friend, Orrin Babcock. Despite Mr. Lovesee's arguments, Babcock continued to insist that he was Lovesee. Finally, the real Lovesee contacted the sheriff at the county seat in the nearby town of Marion.

The sheriff, who was on the alert for Babcock, arrived immediately and put the latter under arrest. Babcock was in a sorry state, having been wandering for three weeks, apparently without food or shelter. At first, Babcock did not remember who he was or what he had done but, under some gentle urging from authorities, gradually came around and admitted his guilt.

Jefferson County sheriff Bart Jones and Undersheriff Gary Kerr traveled to Marion to bring Babcock back to Jefferson County. The sheriff in Marion had warned them to send more than one man, implying that Babcock was hard to handle.

The sheriffs brought him back without incident and lodged him in jail. Babcock reportedly spent most of the next few days sleeping. Authorities gave him time to recover before interrogating him, hoping that Babcock might become more coherent.

Meanwhile, a *Colorado Transcript* reporter was allowed access into the cell to interview him. Babcock wasted no time in giving the reporter his confession: "Yes, I killed my wife and my young son, but I can't tell you why I did it. Something just seemed to say to me that it must be done and I did it."[90]

He told the reporter:

> *I will tell you all I know, but it is pretty hard to do. I can't seem to know that I did such a terrible thing. You know my wife and son were the best in the world. We never had any trouble with one another, and we were all working hard to get ahead in the world. My boy was a good boy. I never had to correct him, even when he was little. My wife was the best and kindest woman in the world. She knew there was something wrong with me at times, but she said we would just go ahead and everything would be all right.*[91]

Babcock even explained what happened:

> *That day my wife had gone to Denver to do some errands, and Vernon and I were fixing a shed or something. Along about dinner time, I think it was, we went into the house and the boy laid down on the bed and went to sleep. I think I was trying to get something to eat. All at once something told me that I must kill him, and I did. I shot him with a rifle, and I don't think he moved. And then I shot him with the shotgun. I think it must have been about half an hour later that my wife came home. It seems to me that I was in the yard when she came. I think we talked together in the house a little bit and then I shot her with the shot gun. I don't remember leaving the house, but it don't seem that I was in a hurry.*[92]

Babcock then wandered off to Kansas, apparently taking several weeks to get there. He said that he remembered nothing of the trip until he arrived at Dodge City. He claimed that he had an uneasy feeling then that "something terrible had happened" but that he couldn't remember what it was. He said he was surprised when Sheriff Armstrong told him that he had killed his wife and son.

He complained to the reporter that the previous incident in Kansas that took place several years in the past should have warned folks that there was something wrong with him and that he should have been institutionalized, "and then this terrible thing would not have happened."[93]

The issue of Babcock's sanity soon caused a rift within the Jefferson County district attorney's office. Shortly after Babcock arrived back in Golden, the deputy district attorney, Charles E. Friend, resigned over the case. Friend felt strongly that Babcock was perfectly sane and did not warrant a psychiatric exam, while his boss, District Attorney W.S. McGintie, insisted that the "lunacy commission" needed to have a look at the fellow and that he was certain Babcock was insane.

McGintie brought in an "alienist," which is a mental pathologist, also referred to at the time as a "mad doctor." The Denver alienist, Dr. George Moline, made a thorough examination of Babcock. He then surprised McGintie by reporting to the court that he judged Babcock to be sane and that the man showed "no signs of a pre-existing state of insanity."[94]

Thus, Orrin Babcock went on trial for the first-degree murder of his wife and son. The court appointed him a public defender, George B. Campbell. Despite the conclusions of Dr. Moline, Campbell decided to plead not guilty on the grounds of insanity. Babcock's trial was set for the following Monday, March 8.

```
Orrin E. Babcock No. 10931. Rec'd March 9th, 1920. From
Jefferson County. Sentenced to Life. For Murder. Age 46.
Weight 178. Height 5.8.1/4. Complexion Med-dark. Bust
39. Waist 40. Thigh 20. Neck 15.1/2. Hat 7.3/8.
Shoes 10. Hair Black. Eyes Grey. Build Med-stout.
Born in Illinois. Nat. American. Occupation Farmer.
Marks and Scars:
Hair thin top of head, slightly bald. Small scar left
jaw. 2 L. upper out, 2 upper front gold crowned. Vac.
mark on R. arm. Sev. boil marks on R. forearm. Scar
back of left hand. Scar R. index finger back on 2nd joint.
Scar inner R. ankle.
Relative:
(Sister) Mrs. George Patterson  Peabody, Kansas.

Finger Print Class'n -----------------------
```

Record of Convict for Orrin Babcock. *Colorado State Archives.*

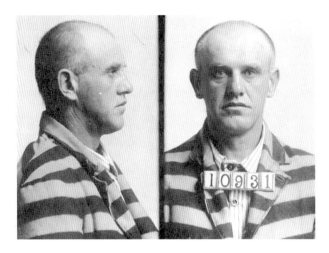

Family and friends ignored signs that something wasn't quite right with Babcock. *Colorado State Archives.*

By the time Monday rolled around, all the necessary deals had been made. Babcock would withdraw his plea of not guilty due to insanity and plead guilty to second-degree murder.

Babcock appeared in court wearing a "heavy disheveled beard." Apparently in a daze, he kept his eyes on the floor and did not make any speeches on his own behalf. When the judge asked him for his plea, he spoke a single word: "Guilty."

Public defender Campbell then addressed the court at some length, pleading for a lenient sentence on the grounds that Babcock did not know what he was doing when he shot his son and wife.

District Judge Samuel W. Johnson remarked dryly that he thought Babcock was getting off lightly, in view of the fact that he wasn't going to the gallows. He sentenced Babcock to the maximum penalty—life in prison.

Before being hauled off to the penitentiary the next day, Orrin Babcock requested that the sheriff take him to the cemetery to visit the graves of his wife and son. Deputy Kerr later reported that Babcock stood over the graves of his slain family with "tears streaming down his face."[95] The following day, Kerr took Babcock to Cañon City.

Two months later, a group from Kansas arrived, including Orrin's brother Thomas T. Babcock from Galva, Kansas, and some cousins. They were settling the affairs of the destroyed Babcock family. The entire household and personal property had already been sold at public auction by the sheriff the previous week.

Orrin E. Babcock spent the rest of his life in prison.

Notes

The Case of the Lovelorn Prodigy (1919)

1. *Colorado Transcript*, March 18, 1920.
2. *Rocky Mountain News*, March 14, 1925.
3. *Colorado Transcript*, March 18, 1920.
4. Ibid., August 25, 1919.
5. *Rocky Mountain News*, March 14, 1925.

Hellion in the High Country (1899 and 1915)

6. *Rocky Mountain News*, July 22, 1915.
7. *Golden Globe*, July 24, 1915.
8. *Colorado Transcript*, November 25, 1915.
9. Ibid.
10. Ibid.
11. Ibid.
12. Ibid.
13. Ibid., June 7, 1889.
14. Ibid., December 6, 1899.

How Deadman Gulch Got Its Name (1871-72)

15. *Colorado Transcript*, July 19, 1871.

THE ORCHITIC STRANGULATOR (1893)

16. *Colorado Transcript*, January 10, 1894.
17. Ibid.
18. Ibid.
19. *Golden Globe*, June 2, 1894.
20. Ibid., May 30, 1894.
21. Ibid., June 13, 1894.

LOVE TRIANGLE AT SHERIE'S RANCH (1923)

22. *Golden Globe*, October 25, 1923.
23. Ibid., November 29, 1923.
24. Ibid., December 13, 1923.
25. Ibid., December 20, 1923.
26. Ibid.
27. Ibid., January 31,1924.
28. Ibid.
29. Ibid., December 4, 1924.
30. Ibid.
31. Ibid., January 22, 1925.
32. Ibid.

MURDER ON TABLE MOUNTAIN (1910)

33. *Colorado Transcript*, November 9, 1911.
34. Ibid.
35. Ibid., December 21, 1911.
36. Ibid., December 28, 1911.
37. Ibid.
38. *Rocky Mountain News*, December 21, 1911.
39. Ibid.
40. Ibid.
41. Ibid.
42. Ibid.
43. *Rocky Mountain News*, December 22, 1911.
44. Ibid., December 24, 1911.
45. *Colorado Transcript*, December 28, 1911.
46. *Rocky Mountain News*, December 24,1911.
47. *Colorado Transcript*, October 19, 1911.

MR. BELLEW RUNS AMUCK (1912)

48. *Colorado Transcript*, August 8, 1912.

A MOST TRAGIC CORNER OF THE COUNTY (1866–1914)

49. *Rocky Mountain News*, February 15,1871.
50. *Arvada Sun*, March 6, 1914.
51. Ibid.
52. *Colorado Transcript*, March 5, 1914.

A MUDDLED CASE OF FRONTIER JUSTICE (1868)

53. Cook, *Hands Up*, 29.
54. *Colorado Transcript*, April 10, 1930.
55. Cook, *Hands Up*, 41.
56. Ibid., 42.
57. *Colorado Transcript*, November 25, 1868.
58. Ibid.
59. Cook, *Hands Up*, 47.
60. *Rocky Mountain News*, November 23, 1868.

MURDER OF THE JUDGE'S SON (1916)

61. *Rocky Mountain News*, June 29, 1916.
62. Ibid., July 27, 1916.
63. Ibid., October 5, 1916.

A DIVORCE MOST FOUL (1883)

64. *Colorado Transcript*, February 14, 1883.
65. *Golden Globe*, February 17, 1883.
66. Ibid.
67. Ibid.
68. Ibid.
69. Ibid.
70. *Colorado Transcript*, February 28, 1883.
71. *Boulder News and Courier*, May 25, 1883.
72. *Rocky Mountain News*, May 24, 1883.
73. Ibid., May 23, 1883.

A CLASH OVER CUCUMBERS (1881)

74. *Golden Globe*, August 24, 1881.

THE MISSING WAGONMASTER (1879)

75. Cook, *Hands Up*, 76.

A HORSE WITH ONLY ONE SHOE (1884)

76. *Fairplay Flume*, December 25, 1884.
77. Ibid., December 11, 1884.
78. *Fairplay Flume*, February 26, 1885.
79. Ibid.
80. Ibid.
81. Ibid.
82. Ibid.
83. Ibid.
84. Ibid.
85. Ibid., May 7, 1885.

THE MYSTERY OF THE CRESCENT POSTMASTER (1918)

86. *Fairplay Flume*, May 2, 1918.
87. Ibid.

THE VOICES MADE HIM DO IT (1920)

88. *Colorado Transcript*, January 22,1920.
89. Ibid., February 12, 1920.
90. Ibid.
91. Ibid.
92. Ibid.
93. Ibid.
94. Ibid., March 4, 1920.
95. Ibid., March 11, 1920.

Bibliography

BOOKS

Cook, David J. *Hands Up. Or, Twenty Years of Detective Life in the Mountains and on the Plains.* Santa Barbara, CA: Narrative Press, 2001.

Mumey, Nolie. *Wigwam: The Oldest Fishing Club in the State of Colorado, With Some History of Douglas and Jefferson Counties.* Boulder, CO: Johnson Publishing Company, 1969.

DOCUMENTS

The Denver Public Library. *Colorado Marriages 1858–1939.* Denver: Colorado Genealogical Society, Inc. 2004.

NEWSPAPERS

Arvada (CO) *Sun*
Boulder (CO) *News and Courier*
Colorado Transcript (Golden)
Fairplay (CO) *Flume*
Golden (CO) *Globe*
Rocky Mountain News (Denver, CO)

WEBSITES

"History of the Jefferson County Sheriff's Office." March 28, 2009. www. co.jefferson.co.us/sheriff/sheriff_T62_R78.htm.

U.S. Census Bureau, 1900. Kaufman County, Texas. http://search.ancestry.com.

U.S. Census Bureau, 1910. Denver County, Colorado. http://search.ancestry.com.

———. Jefferson County, Colorado. http://search.ancestry.com.

U.S. Census Bureau, 1930. Denver County, Colorado. http://search.ancestry.com.

U.S. Census Bureau, 1920. Adams County, Colorado. http://search.ancestry.com.

———. Boulder County, Colorado. http://search.ancestry.com.

About the Author

Carol Turner has a BA in English from Sonoma State University and an MFA in creative writing and literature from Bennington College. She is the author of *Forgotten Heroes and Villains of Sand Creek* and *Economics for the Impatient*. Her short fiction has appeared in numerous literary magazines, and she writes a history column for the *Broomfield Enterprise* in Colorado. Visit her website at www.carol-turner-books.com.

Visit us at
www.historypress.net
..
This title is also available as an e-book